THE GAME

THE MICHIGAN–OHIO STATE
FOOTBALL RIVALRY

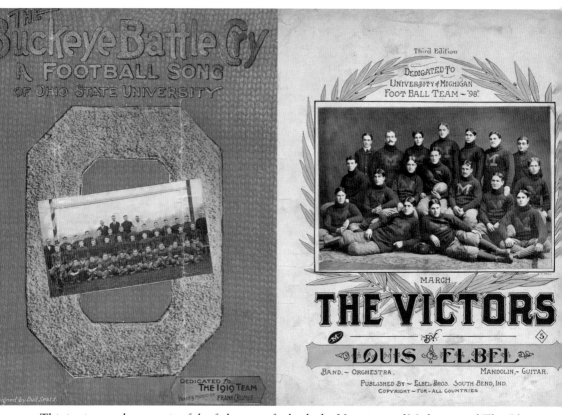

This is vintage sheet music of the fight songs for both the University of Michigan and The Ohio State University. Michigan's "The Victors" is from 1898, and Ohio State's "The Buckeye Battle Cry" is from 1919. The Ohio State marching band, known by Buckeye loyalists as TBDBITL! (The Best Damn Band in the Land!), and the Michigan marching band proudly play their fight song each Saturday as the teams' fans, packed into sold-out stadiums, sing along. (Authors' collection.)

FRONT COVER: Football coaching legends share a moment together before one of their epic battles. At left is Michigan head coach Bo Schembechler, and on the right is Ohio State head coach Woody Hayes. (Chance Brockway.)

COVER BACKGROUND: This postcard photograph shows Ohio Stadium on November 25, 1950, during the battle between Michigan and Ohio State. This contest, the legendary "Snow Bowl," was played in the midst of an 18-inch snowfall. As described by reporters, "It snowed so hard the snow was coming down horizontally." (Ken Magee collection.)

BACK COVER: In an act of pure sportsmanship, and demonstrating the respect these two teams have for each other, Michigan senior quarterback Devin Gardner consoles Ohio State freshman quarterback J.T. Barrett, who suffered a season-ending injury during the 2014 battle. (Greg Bartram, www.betterimage.us.)

THE GAME

THE MICHIGAN–OHIO STATE
FOOTBALL RIVALRY

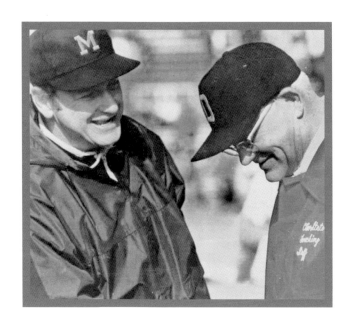

Ken Magee and Jon M. Stevens
Forewords by Dimitrious Stanley and Dr. Billy Taylor

ARCADIA
PUBLISHING

Copyright © 2015 by Ken Magee and Jon M. Stevens
ISBN 978-1-4671-1458-5

Published by Arcadia Publishing
Charleston, South Carolina

Printed in the United States of America

Library of Congress Control Number: 2015944620

For all general information, please contact Arcadia Publishing:
Telephone 843-853-2070
Fax 843-853-0044
E-mail sales@arcadiapublishing.com
For customer service and orders:
Toll-Free 1-888-313-2665

Visit us on the Internet at www.arcadiapublishing.com

To the ladies in my life, my loving Dawn and my wonderful daughter Daniella. I love you both very much.
—Ken

To my "adorable" and loving wife, Kelly. Thanks for always encouraging me and allowing me to indulge in this crazy journey.
—Jon

To the law enforcement officers worldwide who sacrifice themselves for the betterment of the communities in which they serve.
—Ken and Jon

CONTENTS

MICHIGAN FOREWORD

It was my privilege to play for the Michigan Wolverines, in perhaps what is the most historic rivalry in all of college football, if not of all sports. As honored as I have been to be a Wolverine, I am also blessed to have played in one of the greatest upsets in the history of sports, the 1969 Michigan–Ohio State game. As a sophomore tailback, I watched and learned as our first-year head coach, Bo Schembechler, mentored a group of boys into men during the course of that football season. His words still ring true to this day: "Those who stay will be champions." The highlight of my lifetime in sports was competing against the Buckeyes, and I was fortunate to have our team win two of the three games I played in. By far, battling the Buckeyes in this legendary series is the penultimate experience of any Michigan player. Coach Schembechler made us believers, as well as achievers, and his iconic words should define a football player's college career. I greatly respect the Buckeyes and their football tradition, which is the greatest compliment one can give to an opponent. For one day a year in November, when these two teams clash, no matter who is victorious, I am reminded of yesteryear and know that this grand rivalry will live on forever.

—Dr. Billy Taylor

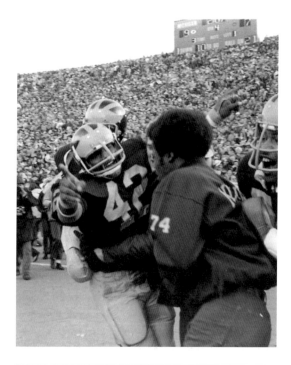

Wolverine Billy Taylor celebrates the game-winning touchdown in the 1971 contest. (Chris Potter.)

OHIO STATE FOREWORD

The Ohio State–Michigan rivalry is something only people who are close to it can truly comprehend. My father, Wayne Stanley, served as the running-back coach at Ohio State in the early 1980s. When you grow up and see it as a kid, it is a completely amazing experience. Years later, having had the opportunity to play wide receiver for The Ohio State University was one of the most phenomenal experiences in my life. The games involved the greatest rivalry, in legendary stadiums ("The Horseshoe" and "The Big House"), against extremely talented Michigan teams. I still remember the hype during the week leading up to the game; the pressure was unlike anything I had ever experienced. In three of the four years that I played, we were undefeated heading into the Michigan game, with national championship aspirations on the line—so the game was that much bigger. And that is what this rivalry should always be: Michigan against Ohio State, two powerhouse college football programs, battling for respect and, of course, for the Big Ten Conference championship.

—Dimitrious Stanley

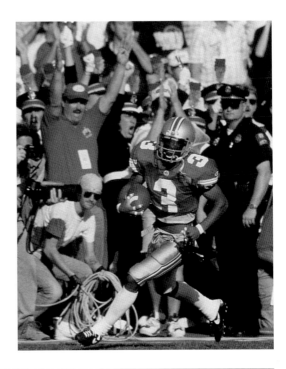

Ohio State Buckeye receiver Dimitrious Stanley runs after making a catch in the 1996 Ohio State–Michigan game. (Chance Brockway.)

ACKNOWLEDGMENTS

For over a century, this historic rivalry has been played. Thousands of players from these two prestigious universities, the University of Michigan and The Ohio State University, have battled on the gridiron for bragging rights until the following year. We would like to thank these players and their coaches—without them, the game would not be played. The contest has become a great and important piece of the fabric of college football. The overall completion of this book could not have been accomplished without the outstanding assistance of Mark Schlanderer; the authors are grateful to Mark, who not only provided focus for the entire project but also offered assistance with his painstaking fact-checking and intricate knowledge of the game of football. Following up Mark's hard work was Patrick Friedrich, who is an accomplished football historian.

A project of this magnitude utilizes images from many resources; abbreviations for each source will be found in parentheses at the end of the caption unless otherwise specified. We would like to thank the University of Michigan Bentley Historical Library (BHL), specifically Karen Jania, division head of reference, and her helpful, talented staff, as well as archivists Greg Kinney and Brian Williams, who contributed so much to the success of this project. Other contributors from Michigan who were helpful to us and provided input and substance to the project are Jim Parker, Bob Rosiek, Michael Alley (MA), John Harrison (JH), Charles Bernard Jr. (CBJ), Greg Dooley (GD), Chris Potter (CP), H. Sosa (HS), Karl and Amy Lagler, Jeff Allen (JA), and Jade Peddie (JP). Thanks go to Heisman Trophy historian Karey Lavin (KL) and to Michigan superfan Jeff Holzhausen (SF), for being himself! From the great state of Ohio, we would like to thank Vlade Janakievski (VJ), as well as Steve Green from Check List Sports, for assisting in the collection of images. OX Studio in Ann Arbor allowed us access to office space and resources. Thanks also go to professional photographers Bob Kalmbach (BK), Chance Brockway of Brockway Sports Photos (CB), Greg Bartram of www.betterimage.us, and Joseph Arcure (JA). They understand that the photographs of today capture and memorialize college football's greatest moments for eternity. In addition, we would like to thank media outlets *The Cleveland Plain Dealer*, *The Columbus Dispatch*, and *The Michigan Daily*.

On a final note, the number of Ohio State and Michigan players and coaches who have received various college football awards is extremely voluminous. The authors extend our sincere apologies that space did not permit us to identify every recipient in our commentary.

INTRODUCTION

In late 1999, in celebration of a new century, ESPN studied the great rivalries in all of sports and created a top-10 list. The number-one choice for sport's greatest rivalries was the Michigan–Ohio State football game. This great rivalry has now spanned 111 games. Prior to the first game in this series in 1897, Michigan had been playing for almost 20 years, with their first game in 1879, defeating Racine College. This victory was only 10 years after the very first college football game, played in 1869 between Princeton and Rutgers. Ohio State played its first game in 1890, beating Ohio Wesleyan College. It was in 1897 that Michigan met Ohio State on the gridiron for the first time. This historic rivalry has resulted in 58 Michigan wins, 47 Ohio State wins, and six ties. Since 1919, when Ohio State achieved its first win against Michigan, the series record stands as follows: 47 Ohio State wins, 45 Michigan wins, and four ties. The two teams have combined for 19 national championships and 77 Big Ten Conference championships and produced 10 Heisman Trophy winners and hundreds of All-Americans. While many great rivalries have a trophy to symbolize victory, the prize in the Ohio State–Michigan game is simply bragging rights.

As storied as the rivalry is between these two football giants, so are their nicknames, fight songs, and traditions. The team nicknames, the Wolverines of Michigan and the Buckeyes of Ohio State, have lore attached to both universities. Wolverines has been used since the 1860s. Michigan is known as the "Wolverine State," and there are many theories as to its original designation for both the state and the university. They range from when the French settled in Michigan in the 1700s to a battle over a border dispute between Michigan and Ohio in 1803. It is certain that a wild wolverine is a rare occurrence in Michigan, and there has never been an example of skeletal remains or a trapping of a live wolverine in the state. Only once since the 1800s, in 2004, has a wolverine been verified as living in the wild in the state. Fielding Yost embraced the nickname, going so far as to bring caged wolverines from the Detroit Zoo to Michigan Stadium in 1927 to parade them in front of spectators.

The nickname Buckeyes originated from the fact that Ohio's nickname is the "Buckeye State." In addition, due to the popularity of the buckeye tree and its prevalence throughout the state, in 1953 the buckeye tree was designated as the state tree. The word "buckeye" has a connection with the Native American word *hetuck*, meaning "buck eye," as the markings of the buckeye nut resemble the eye of a deer. Although historians show that Buckeyes was used for residents of Ohio as early as 1788, it was not designated as the official nickname of The Ohio State University until 1950.

With respect to the Michigan rivalry, the Buckeyes started a custom in 1934. The "Gold Pants" tradition was started by Ohio State first-year coach Francis Schmidt. A gold pants charm is awarded to Ohio State players who defeat the Wolverines. Once, when Coach Schmidt was asked how his team could defeat the Wolverines, he responded, "They put their pants on one leg at a time, like everybody else." Following that 1934 claim, the Buckeyes defeated Michigan four straight years,

outscoring the Wolverines 114-0. Since then, a gold charm in the image of a pair of football pants has been awarded to each player and coach of the teams that defeat the Wolverines.

Another dynamic fact that exemplifies the greatness of this rivalry and the respect the two teams have for each other comes in the form of the marching bands, who incorporate school spirit with each note played. Spelling out the script "Ohio" is legendary when the Buckeye marching band performs on the field. The honor of dotting the "i" goes to a selected sousaphone player, and it is the pinnacle experience of his or her career. The tradition of the script "Ohio" was actually performed first by the Michigan marching band as a tribute to the Ohio State marching band during the 1932 game in Columbus, when the University of Michigan band performed in front of 40,700 spectators. Members marched in block formation and spelled out "Ohio" in script, diagonally across the field with a dotted "i." In 1936, the Ohio State band, with a new formation designed by director Eugene Weigel, performed the first script "Ohio" in the band's storied history. It has evolved throughout the years to now include the triple revolving block "Ohio" as the lead formation, peeling off into the script movement, the interlaced shoestring progression performed to the pervasive driving beat of the venerable "Le Regiment de Sambre et Meuse" and the much celebrated dotting of the "i."

A description of these two great universities would not be complete without mentioning the school colors. Ohio State adopted its official color scheme in 1878, when a committee of three students gathered in University Hall to select a combination. The first choice was orange and black, but the committee learned that Princeton was using these colors and thus quickly discarded the idea. They then moved to select the now-famous scarlet and gray because they thought it was a nice combination and unique. Michigan selected its colors in 1867 after a group of students chose azure blue and maize as emblematic of the university, which is now the legendary maize and blue. The colors are adorned by Buckeye and Wolverine players and fans worldwide. On game day, at the Horseshoe in a sea of scarlet and gray or at the Big House in the land of maize and blue, there is no doubt as to who the home team is.

The dynamic fight songs of both universities stir emotion and pride as they conjure up images of yesteryear. University of Michigan student Louis Elbel penned "The Victors" after a major football victory over the University of Chicago in 1898. Elbel was traveling back to Ann Arbor after the Chicago game when he completed the lyrics. The following year, John Phillip Sousa and his band traveled to Ann Arbor to perform at University Hall. Elbel provided a copy of the music to Sousa, who had his band play "The Victors" for its debut on April 8, 1899. The Ohio State fight song, "The Buckeye Battle Cry," was written by songwriter Frank Crumit, an Ohio State alumnus. The song was a contest winner in 1919 while planning the construction of Ohio Stadium. The lyrics end with a resounding "O-HI-O!" History has proven that, at the end of each battle, whoever is victorious, be it the Wolverines or the Buckeyes, the fight song is sung proudly by players and fans alike, who cherish their dedication to these two great universities.

Go Bucks! Go Blue!

THE FIRST GAME
1897

When the Ohio State Buckeyes traveled to Ann Arbor, Michigan, to play the Wolverines on October 16, 1897, it would be hard to comprehend that this game would begin one of the most important rivalries in the history of college football. The Wolverines were fielding their 18th varsity football team since they began playing the sport in 1879. By contrast, this was the Buckeyes' eighth team since football became a varsity sport in Columbus in 1890. The game was played at Regents Field in Ann Arbor. The Michigan squad, coached by Gustave Ferbert, proved to be too much for the Ohioans. This first battle was essentially over in the first half, as Michigan scored 34 unanswered points on six touchdowns and five conversions. At the time, a touchdown was worth four points, conversions were two points, and a field goal earned four points. A half was limited to 20 minutes. The Buckeyes made corrections at halftime, which, combined with Michigan playing substitutes and not pursuing any aggression on offense, resulted in no more scoring. The second half was only played for 15 minutes, as Coach Ferbert and first-year Ohio State coach Dave Edwards decided to end the game early. The Wolverines won the first battle 34-0, establishing a trend that lasted for two decades, as the Buckeyes did not secure a single victory over the Wolverines until 1919.

'VARSITY TAKES A BRACE.

Ohio State University Defeated by a Score of 34 to 0.

Michigan had no trouble in defeating the Ohio State University representatives in Saturday's game. Two halves of 20 and 15 minutes respectively were played and the score was 34 to 0. It was not so much Michigan's strength as Ohio's weakness that brought about the score. The visitors lined up with three of their best players absent, while Michigan put her best team in the field. While the form of the 'varsity team was not on the championship order it showed an improvement over that of the Saturday before that was most encouraging. The interference was better, the playing snappier and the defensive work stronger than ever before. In the line the work of Caley at guard was especially strong. Caley opened holes of the biggest kind in Ohio's line and made interference that repeatedly enabled the backs to make long runs. Snow at the other guard position also showed up strong. Lehr, Juttner and Baker were on a par at tackle, and it was through these positions that the Ohioans made most of their gains. Bennett, Teetzel and Ayres on the ends were stronger than ever, but still somewhat weak on defensive work. All of the backs played great ball. Hogg bucked the line hard and went around the ends for consistent gains. Stuart, who played for the first time, has the longest runs to his credit, due to the way in which he followed his interference. Pingree made several good gains and a dash of 50 yards across Ohio's goal was annulled by Baker's off-side play. Talcott at quarter also played for the first time and did well. His passing was surer than any he has shown in practice. In the first half a high wind favored Ohio, but they had only two or three opportunities to take advantage of it, as Michigan kept possession of the ball through almost the entire half. All of Michigan's points were made in this half.

Hannan kicked off and the ball downed on the 25 yard line. Ohio kicked to middle of the field. Hogg made 5 yards, Stuart 5 and then 10, Hannan 5, Hogg 10, Hannan 2, the ball was fumbled but regained for 3 yards gain. Hogg advanced 5 and Hannan 10 for a touchdown. Hogg kicked goal. Score 6 to 0. Time 6 minutes.

Ohio kicked to Stuart at the 10 yard line and he came back 20 before being downed. Bennett went around the end for 4 yards. Teetzel skirted the end for 5 and followed with a gain of 4. Hogg then went around the end for 32 yards behind interference, but was stopped by a star tackle by Captain Hawkins, Ohio's full back. Stuart made 5 through the line, Bennett made 4, Stuart 15 more, Hogg 5, Hannan 5 and Stuart went over for the second

touchdown. Hogg kicked goal. Score 12 to 0. Time 9 minutes.

Hawkins kicked off to Michigan's 40 yard line and Talcott brought it back 20 yards. Hogg gained 5, Stuart 8, Hogg 12, Stuart 5 and then 16, Hogg 23, Hannan 4, Hogg 4 and then across goal, for the third touchdown. He kicked a hard goal. Score 18 to 0. Time 12 minutes.

Another touchdown was made in two minutes by Stuart by a run of 26 yards. Previous to this Hannan had made gains of 22 and 4 yards, Stuart 15, Hogg 8, 4, 6 and 9, Bennett 7 and Teetzel 8. Hogg missed goal. Score 22 to 0. Time 14 minutes.

Stuart also made the fifth touchdown after making gains of 23 and 21 years. Talcott made a long gain of 35 yards in the kick-off. Bennett made an end run of 15 yards. Hogg kicked goal. Score 28 to 0. Time 16 minutes.

After Hannan, Juttner and Stuart had made gains of 10, 15 and 9 yards respectively, Stuart was taken out and Pingree put in. Hogg made 4, Pingree 12, Hogg 3, Teetzel 10, Bennett failed to advance, Pingree 12, and Hannan 23. Off-side play here gave the ball to Ohio, who punted for a gain of 20 yards. Hannan made 8, Pingree and Juttner 5 each and then Pingree crossed goal for a touchdown. Goal was kicked. Score 34 to 0. Time 19 minutes.

After the kick-off Michigan advanced the ball to the 20 yard line, where Hannan attempted a field goal in which he failed. Ohio got the ball and made a gain of 5 yards as time was called.

In the second half Michigan played for the most part a kicking game, putting Ohio on the offensive. Hogg was hurt in this half and retired, McLain coming in. The largest gain made by Ohio was of 7 yards. Others ranged from 1 to 5 yards and were few. Neither side scored in this half and when time was called the ball was in Michigan's possession on Ohio's 15 yard line.

For Ohio the best playing was done by Hawkins at full-back, Jones at center and Saxby at center. The entire team played gentlemanly ball and not a single wrangle arose to mar the game. The team is coached by Edwards, Princeton, '96. Several members of the Ohio faculty accompanied the team.

The line-up follows:

Michigans.		Ohios.
Teetzel	L. E.	Engelsberger R. E.
Lehr	L. T.	Rios R. T.
Snow	L. G.	Urban R. G.
Savage	C.	Jones C.
Caley	R. G.	Mackay L. G.
Jutner	R. T.	Miller L. T.
Bennett	R. E.	Schribber L. E.
Talcott	R. H. B.	Saxby Q. B.
Stuart	L. H. B.	Purdy R. H. B.
Hogg	R. H. B.	Benedict L. H. B.
Hannan	F. B.	Hawkins F. B.

Substitutes — For Michigan: Ayers for Teetzel, Baker for Jutner, Pingree for Stuart, McLean for Hogg. For Ohio: Bake- for Jones, Culbertson for Urban. Touchdowns—Stuart (3), Hannan, Hogg, Pingree. Goals from touchdowns—Hogg, 5. Officials—Knight, Princeton; Wilson, Ypsilanti.

The next game will be with Oberlin next Saturday.

The S. L. A. board has elected an auditing committee composed of Profs. T. E. Trueblood, Downey L. Harris and Clarence G. Whitney.

This October 18, 1897, newspaper article from *The Michigan Daily* describes the very first game between the University of Michigan and The Ohio State University. The contest was played at Regents Field in Ann Arbor on October 16, 1897. The Wolverines were victorious, 34-0. (BHL.)

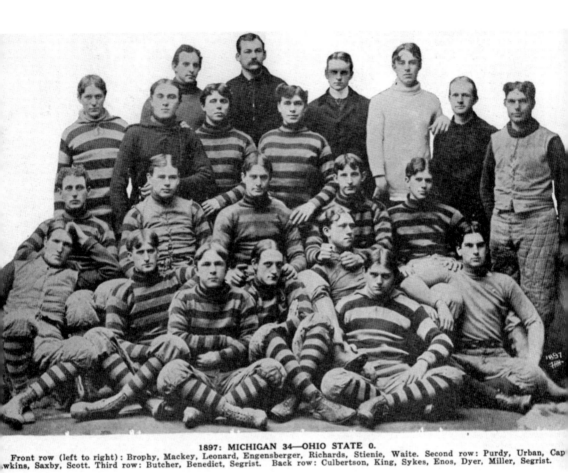

1897: MICHIGAN 34—OHIO STATE 0.
Front row (left to right): Brophy, Mackey, Leonard, Engensberger, Richards, Stienie, Waite. Second row: Purdy, Urban, Cap wkins, Saxby, Scott. Third row: Butcher, Benedict, Segrist. Back row: Culbertson, King, Sykes, Enos, Dyer, Miller, Segrist.

The 1897 Ohio State University football team was led by coach David Edwards and team captain Harry Hawkins. (BHL.)

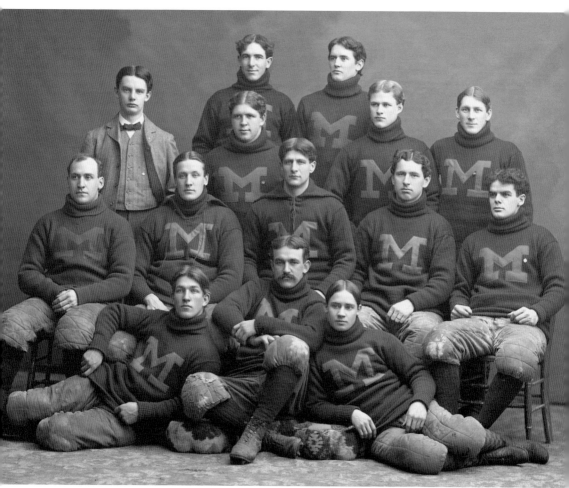

The 1897 University of Michigan football team was led by coach Gustave Ferbert and captain James Hogg. (BHL.)

2

An Upset Tie Game, Then Michigan Dominates

1900–1918

It was 1900 when the Buckeyes and Wolverines met again. A favored Michigan team hosted the game at Regents Field in a major snowstorm. Hundreds of Ohio State rooters arrived in several train cars. Ann Arbor had not seen such school spirit from any opponent they had ever faced. The game, which ended in a scoreless tie, would today be considered an instant classic. It gave Ohio State instant credibility among college football pundits, as they outplayed Michigan in every statistic except the score. The coming years would tell a different story, however, as Ohio State continued to grow and mature as a football program. The Wolverines landed a brash young coach by the name of Fielding Yost, who would lead Michigan to six national championships, including four in a row (1901–1904). Ohio State would be thwarted by Michigan over the next two decades; the Wolverines won the next 12 games and tied only once through 1918.

O.S.U vs U. of M.
GREAT FOOT BALL GAME
AT
ANN ARBOR, MICH.
$2.40 ROUND TRIP $2.40

SATURDAY, NOV. 24, 1900

Special Through Trains both ways via Ohio Central Lines and Ann Arbor Railway

Train Leaves Broad St. Station 6:00 A. M. Returning Leaves Ann Arbor 6:00 P. M.

GO WITH THE BOYS AND HELP WIN THE GAME!

Get tickets at KILLER'S PHARMACY, Cor. 5th Ave. and N. High St., or CITY TICKET OFFICE, 205 North High Street

reduced Rate Fares can not be accepted by Conductors on trains. Passengers to obtain this concession must you have tickets at Ticket Office.

W. PETERS, Traveling Pass. Agt. S. G. HARVEY. Pass. Agt. MICH. TICH. OWN, Gen. Pass. Agt.

This 1900 poster advertises the train transporting fans from Columbus to the game in Ann Arbor. At Regents Field, 3,000 spectators braved the snow and sleet as the two teams battled to a scoreless tie. (Jon Stevens collection.)

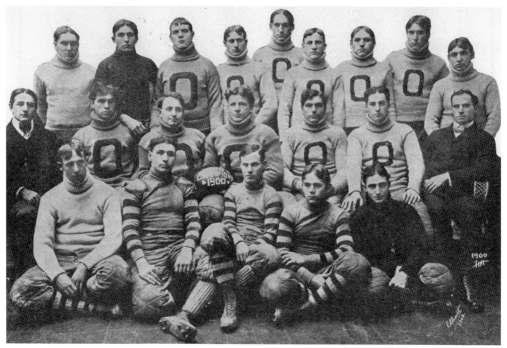

The 1900 Ohio State team photograph team with member Lynn St. John (third row, far left), who went on to become the school's first athletic director in 1912. That year, Ohio State became a member of the Big Ten Conference. (Jon Stevens collection.)

Michigan's All-Americans William Cunningham (holder) and Neil Snow (kicker) appear in this vintage photograph. Cunningham was named Michigan's first All-American, in 1898, and Snow earned the honor in 1901. Snow was inducted into the College Football Hall of Fame in 1960. (Ken Magee collection.)

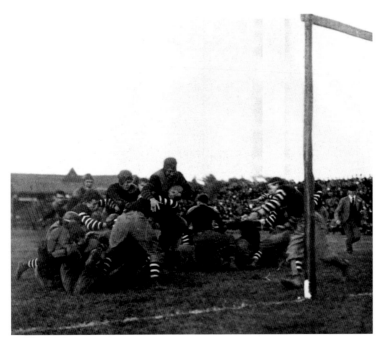

The 1901 Michigan–Ohio State game, depicted here, was played in front of 3,300 spectators at University Field in Columbus. The Wolverines defeated the Buckeyes 21-0 behind touchdowns by Neil Snow (who scored twice), Hugh White, and Willie Heston. (BHL.)

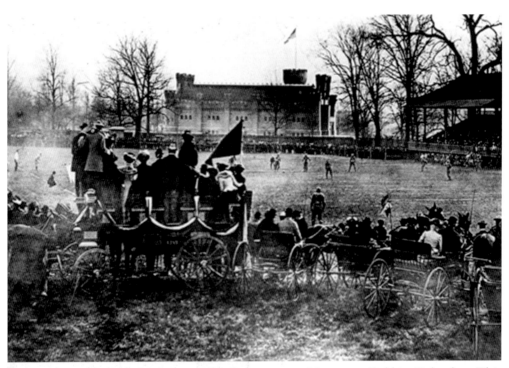

Shown here is the 1901 Michigan–Ohio State game at University Field in Columbus. This photograph vividly portrays the spectator scene on the day of the game. The Ohio State crowd was introduced to Coach Yost's first "point-a-minute" team. The Buckeyes lost the game, but they held Michigan to only 21 points. (BHL.)

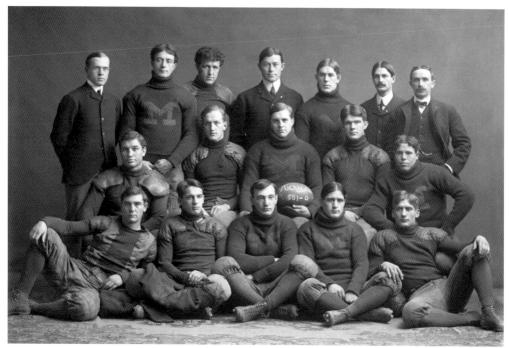

The 1901 University of Michigan national champion football team was led by first-year head coach Fielding Yost. Known as the "point-a-minute team," Michigan was undefeated (10-0) for the season and outscored its opponents 501-0. The Wolverines went on to play in the inaugural Rose Bowl game in Pasadena, California, defeating Stanford 49-0 on New Year's Day in 1902. (BHL.)

This c. 1900 postcard shows Michigan coach Fielding Yost. He went on to guide the Wolverines to six national championships, compiling a record of 165-29-10. A little-known fact is that Yost had applied to be the head coach of Ohio State in 1897. He was rejected for that position, instead becoming coach at Ohio Wesleyan. Near the end of Yost's coaching years, he became the athletic director in 1921 and is credited with envisioning and completing the construction of Michigan Stadium. Yost was inducted into the College Football Hall of Fame in 1951. (Ken Magee collection.)

Michigan halfback Al Herrnstein was the star of the 1902 game in Ann Arbor, scoring a record five touchdowns against the Buckeyes in an 86-0 rout. This touchdown record still stands, but it was tied by Michigan teammate Herb Graver in the 1903 game against the Buckeyes. Although a star at Michigan, Herrnstein went on to be the head football coach at Ohio State from 1906 to 1909. He was 0-4 against his alma mater. (BHL.)

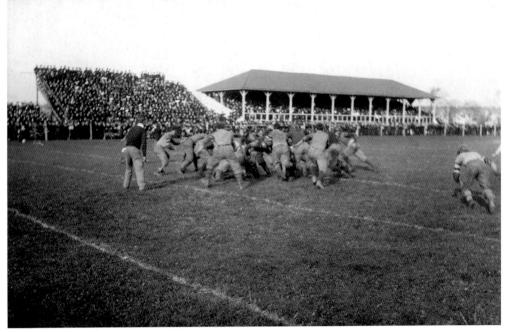

This photograph shows action from the 1902 game, which was played at Regents/Ferry Field in Ann Arbor. (BHL.)

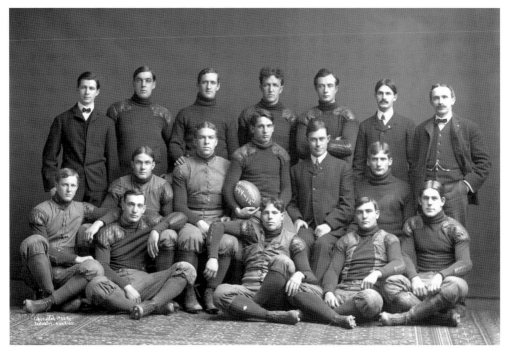

The 1902 University of Michigan national champion football team was led by second-year head coach Fielding Yost. The Wolverines outscored their opponents 644-12 and were undefeated, winning 11 games on the way to their second consecutive national championship. (BHL.)

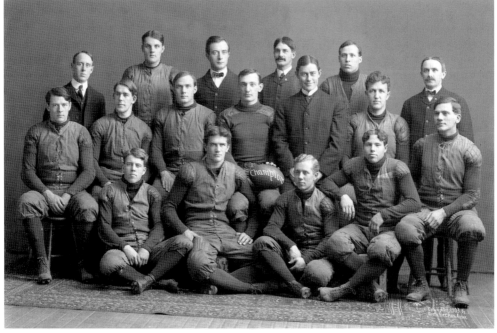

The 1903 Wolverines were the third consecutive national championship team for Yost. The Wolverines defeated the Buckeyes 36-0 in Ann Arbor at Regents/Ferry Field. (BHL.)

In 1904, the Wolverines defeated the Buckeyes 31-6 at University Field in Columbus. In this game, Buckeye fullback Bill Marquardt scored the first touchdown for Ohio State in the history of the series. That year's Michigan squad (pictured) won the school's fourth consecutive national championship. (BHL.)

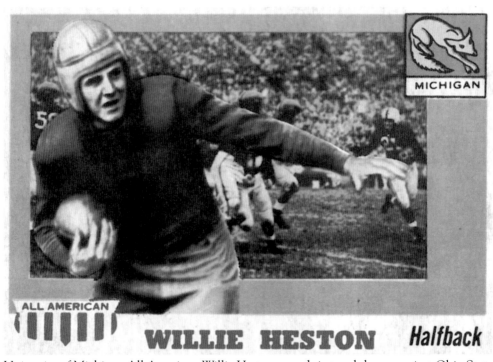

University of Michigan All-American Willie Heston scored six touchdowns against Ohio State in his career (1901–1904). This style of trading card from the 1950s honors college football's historic All-Americans. Heston was inducted into the College Football Hall of Fame in 1954. (Ken Magee collection.)

FOOT BALL EXCURSION

MICHIGAN VS.

OHIO STATE UNIV.

AT

COLUMBUS, OHIO

SATURDAY, OCT. 20

$3.25 Round Trip $3.25
Including General Admission to Game

SPECIAL TRAIN via.

Ann Arbor Railroad and Hocking Valley Ry.

Leave ANN ARBOR 7:40 a.m.
Arrive COLUMBUS 11:40 a.m.

Returning Special Train will leave Columbus at 7:00 p.m.
arrive at Ann Arbor about 11:30 P. M.

The Sale of 200 Tickets is necessary to secure these arrangements. Those wishing to take advantage of these low rates are urged to procure their tickets at once, that ample train accommodations may be arranged for. Tickets on sale at Office of Athletic Association, 424 South State St., and at the Ann Arbor Railroad Station.

Passengers desiring seats in Parlor Car are requested to make reservation in advance at ticket office. Ann Arbor Railroad Station.

CHAS. BAIRD, Graduate Director

MILLARD, The Printer

This 1906 poster advertises the train from Ann Arbor to Columbus. The Wolverine fans would not be disappointed, as Michigan won the game 6-0. Michigan went on to win the Big Ten Conference, but the school would drop out of the conference at the end of the 1906 season. It was also the first game that former Michigan football star Al Herrnstein coached the Buckeyes. (Ken Magee collection.)

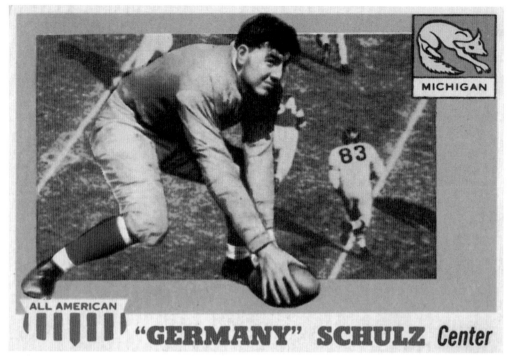

"GERMANY" SCHULZ Center

Michigan's Germany Schulz appears on this All-American trading card. Schulz established the defensive linebacker position and was an All-American in 1907. He was inducted into the College Football Hall of Fame in 1951. (Ken Magee collection.)

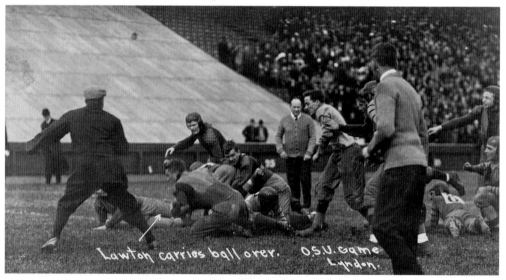

This 1909 postcard shows Wolverine fullback George Lawton in action. Michigan hosted Ohio State at Ferry Field and won decisively, 33-6. Michigan was led by captain Dave Allerdice, who scored a touchdown and kicked three field goals. Stanfield Wells and Lawton each added a touchdown. This marked the fourth consecutive loss for Ohio State and coach Al Herrnstein, who was replaced the following year by Howard Jones. (Ken Magee collection.)

This is the program for the October 22, 1910, game in which Michigan traveled to Columbus. The two teams met on Ohio Field and could only muster one field goal apiece, battling to a 3-3 tie, the second deadlock in the series. Ohio State was guided by first-year head coach Howard Jones, who would lead the Buckeyes for only one year. He went on to coach at the University of Iowa and the University of Southern California. Jones was inducted into the College Football Hall of Fame in 1951. (HS.)

In the 1910 game, the Michigan line on both offense and defense was anchored by two-time All-American guard and team captain Al Benbrook. He was inducted into the College Football Hall of Fame in 1971. (BHL.)

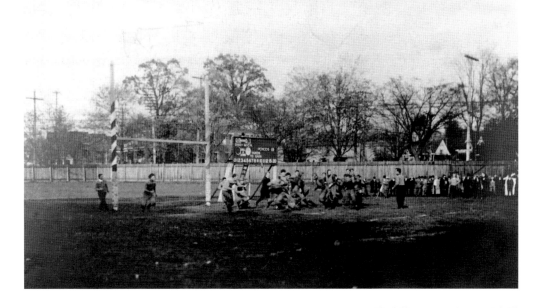

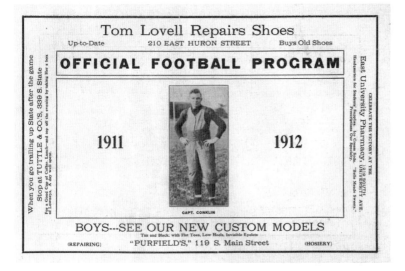

On October 21, 1911, with 5,000 spectators at Ferry Field, the Wolverines defeated the Buckeyes 19-0. Michigan kept its unbeaten streak against Ohio State alive (11 wins and two ties). This is the program for the 1911 game. (Ken Magee collection.)

The October 19, 1912, contest was advertised as the "final meeting" between the two schools. Ohio State had joined the Big Ten Conference and would start play in 1913. Big Ten members were barred from playing Michigan, which had withdrawn from the conference six years earlier. The Wolverines defeated the Buckeyes 14-0 at Ohio Field for what was the final game until Michigan rejoined the Big Ten Conference five years later. They would resume the rivalry in 1918. (Ken Magee collection.)

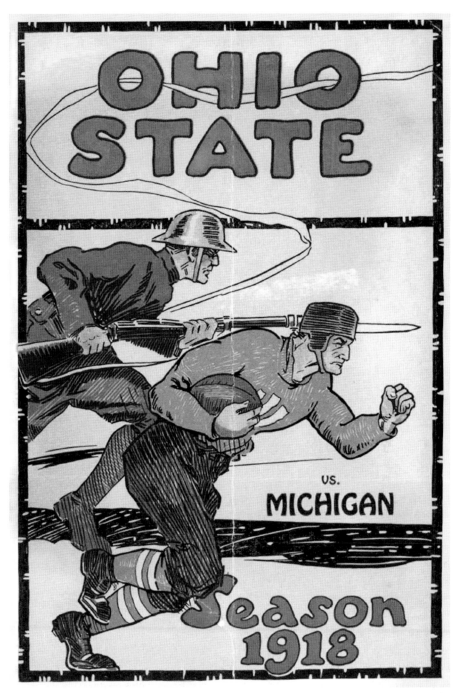

This is the program for the November 30, 1918, game in which Michigan traveled to Columbus and won in a hard-fought battle. Ohio State was without the services of All-American Chic Harley, who had left school that year for the armed forces at the end of World War I. In 1916 and 1917, Harley led the Buckeyes to two Big Ten Conference championships, with 7-0 and 8-0-1 records, respectively. Harley returned to Ohio State for his final year in 1919. (Ken Magee collection.)

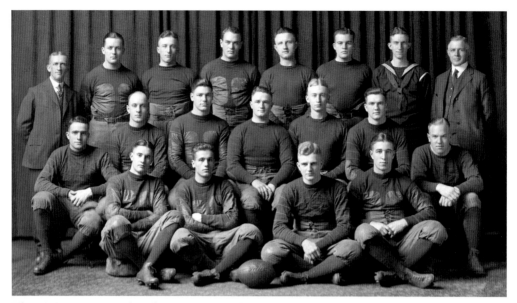

The 1918 University of Michigan national champion football team poses for a photograph. The Wolverines won the national championship with a 5-0 record in a shortened season due to World War I and a nationwide flu epidemic. The Wolverines defeated the Buckeyes 14-0 in front of 7,000 spectators on a frigid November Saturday afternoon in Columbus. Michigan was led by freshman fullback Frank Steketee (third row, second from left). He was the first player in Michigan football history to be named All-American in his freshman year. (BHL.)

This postcard shows Ferry Field, the home for the University of Michigan football team from 1906 to 1926. The field was located at the corner of Hoover and South State Streets on Michigan's campus. The site is now occupied by an outdoor track, located directly behind the Intramural Building. On this track in 1935, Ohio State athlete and Olympic gold medalist Jesse Owens broke or tied five world records in the span of 45 minutes. It is considered one of the greatest achievements in all of sports. (Ken Magee collection.)

3

THE BIG GAME RIVALRY CONTINUES

1919 – 1950

In 1919, Ohio State finally secured its first victory over Michigan, by a score of 13-3. The record during the next three decades was much more equal: Michigan would win 18 games, Ohio State won 12, and there would be two ties. The schools agreed, starting in 1935, that their rivalry game would be the last conference game of the regular season. This tradition has been maintained every year, with the exception of 1942, when Michigan played Iowa and Ohio State played Iowa Pre-Flight as their last games. This era saw six national championship squads for both teams. Ohio State won its first national championship in 1942, and Michigan won five championships under four different coaches. The era saw three Heisman Trophy winners: Michigan's Tom Harmon (1940) and Ohio State's Les Horvath (1944) and Vic Janowicz (1950). The 1920 Ohio State team went to the Rose Bowl and played the University of California but came up short, 28-0. Soon after, the Big Ten Conference made the decision that there would be no more postseason bowl games for any Big Ten school. The decision was finally reversed in 1946, when the Big Ten and the Pacific Coast Conferences entered into an agreement to only play each other in the Rose Bowl. This agreement lasted for over a half century until the Bowl Championship Series (BCS) emerged in 1998 and playoffs started in 2014.

There can be no bigger compliment than to invite one's biggest rival to play in the dedication game of a new football stadium. In 1922, Ohio State dedicated its new Ohio Stadium by playing Michigan in front of 71,000 spectators. Michigan spoiled the party, defeating the Buckeyes 19-0. Michigan returned the favor, hosting Ohio State in 1927 for the dedication of Michigan Stadium in front of 84,401 spectators. The Wolverines won, 21-0. Over time, these two historic stadiums have been referred to as "The Horseshoe" and "The Big House."

The series has also produced what is considered one of the most bizarre games ever played. The 1950 game, dubbed the "Snow Bowl," resulted in a 9-3 victory for Michigan—despite the Wolverines not registering a single first down. The victory sent Michigan to the 1951 Rose Bowl.

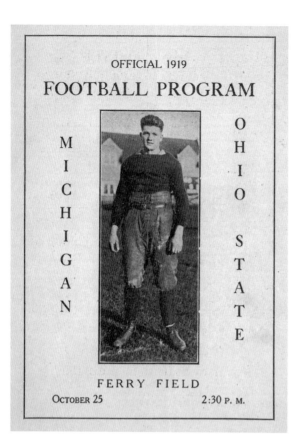

OFFICIAL 1919

FOOTBALL PROGRAM

M
I
C
H
I
G
A
N

O
H
I
O

S
T
A
T
E

FERRY FIELD

OCTOBER 25 2:30 P. M.

On October 25, 1919, Ohio State secured its first victory in the series, ending 22 years of frustration by defeating the Wolverines 13-3. Shown here is the program for the game, which was played in Ann Arbor. A blocked Wolverine punt, recovered in the end zone, resulted in the first Buckeye touchdown. The victory was secured when three-time All-American halfback and team captain Chic Harley scored the second touchdown, racing 42 yards before a stunned crowd of 25,000 at Ferry Field. After the game, Coach Yost made an unprecedented visit to the Ohio State locker room to congratulate the Buckeyes, and specifically Harley, on the victory. (Ken Magee collection.)

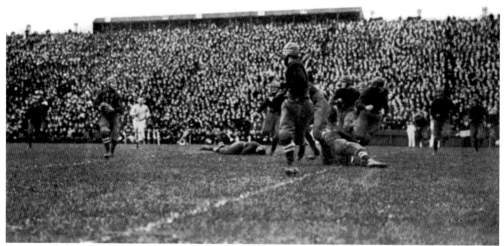

Ohio State Buckeye and three-time All-American Chic Harley is shown with the football in this photograph. His first name was Charles, but he earned the nickname "Chic," as he hailed from Chicago. Harley is considered one of the greatest players in the history of college football. He was inducted into the College Football of Fame in 1951, and his uniform no. 47 was retired by the Buckeyes in 2004. (BHL.)

On November 6, 1920, the Buckeyes secured their second straight victory over the Wolverines, winning 14-7 in front of the Columbus crowd. The Buckeyes posted a record of 7-0 for the season and won the conference championship. Invited to Pasadena to play in the Rose Bowl on January 1, 1921, the Buckeyes lost to the University of California 28-0. On June 21, 1921, the Big Ten Conference adopted a policy prohibiting postseason games for its members. This rule lasted for 25 years, prior to the 1947 Rose Bowl. (Ken Magee collection.)

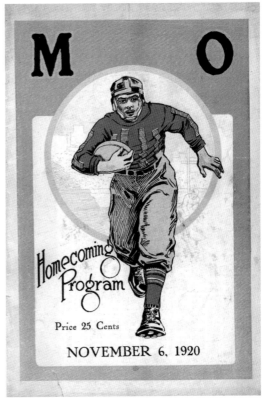

Homecoming Program

Price 25 Cents

NOVEMBER 6, 1920

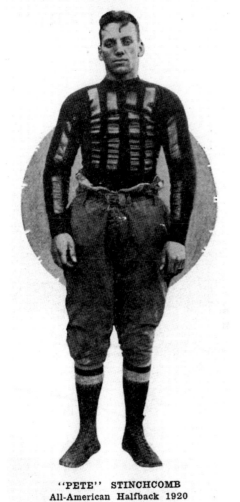

"PETE" STINCHCOMB
All-American Halfback 1920

Ohio State All-America halfback Gaylord "Pete" Stinchcomb is seen here in 1920. He combined with three-time All-American Chic Harley in 1917 and 1919 to form a star backfield unit. With Harley's graduation in 1920, Stinchcomb combined with quarterback Hoge Workman to develop a passing attack to compliment his running skills. Stinchcomb was inducted into the College Football Hall of Fame in 1973. (Ken Magee collection.)

Many fans traveled from Ann Arbor to Columbus in 1922 to take part in the dedication game of Ohio Stadium. Wolverine fans would be rewarded, as their team spoiled the dedication event, defeating Ohio State 19-0. (Ken Magee collection.)

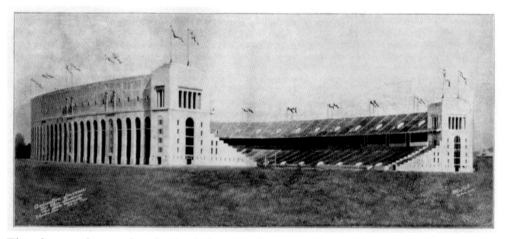

This photograph was taken for the dedication of the new Ohio Stadium. Because of its shape, the stadium is to this day commonly referred to as "The Horseshoe." Opening in 1922, it was immediately considered one the finest stadiums in the country. It has been written that momentum to secure overall funding for Ohio Stadium, which cost $1.34 million, was based on the recent success of the Buckeyes. Of course, equally as important was defeating the Wolverines soundly. (Ken Magee collection.)

Shown here is the program for the 1922 game, played on October 21. Over 70,000 spectators attended the game, played during homecoming weekend and designated as the dedication game for the new Ohio Stadium. Seated amidst the largest crowd ever to watch a Michigan–Ohio State game, the few Michigan fans in attendance were rewarded for their travel to Columbus: the maize and blue defeated the scarlet and gray 19-0. The Wolverine victory was based largely on what is considered one of the greatest performances in Michigan football history. All-American Harry Kipke intercepted two passes, one for a touchdown, and scored another touchdown on a 26-yard run. He also booted a field goal. Kipke pinned the Buckeyes deep in their own territory by punting 11 times, averaging 47 yards a punt, with nine punts landing inside the Buckeye 8-yard line. (Ken Magee collection.)

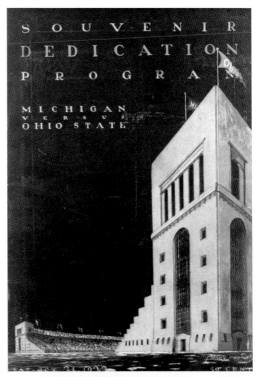

This photograph was taken during the 1922 Ohio Stadium dedication game in Columbus. (BHL.)

All-American Harry Kipke was an outstanding athlete who won nine letters for the University of Michigan in football, baseball, and basketball. He is credited with single-handedly defeating the Buckeyes in the 1922 game in Columbus with what was considered one of the greatest performances in Michigan football history. The team captain in 1923, Kipke later went on to become the Wolverines' head football coach, winning national championships in 1932 and 1933. He was inducted into the College Football Hall of Fame as a player in 1958. (BHL.)

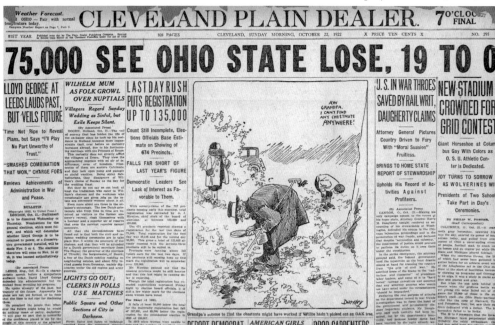

The *Cleveland Plain Dealer* headline of October 22, 1922, sums up the dedication game of Ohio Stadium in Columbus. (*The Cleveland Plain Dealer.*)

In the 1923 game, the Wolverines defeated the Buckeyes 23-0 in front of a sold-out Ferry Field crowd of 50,000. The Wolverines went on to win the Big Ten Conference championship, as well as the 1923 national championship, with an 8-0 record. Shown here is the program for the October 20, 1923, contest. (Ken Magee collection.)

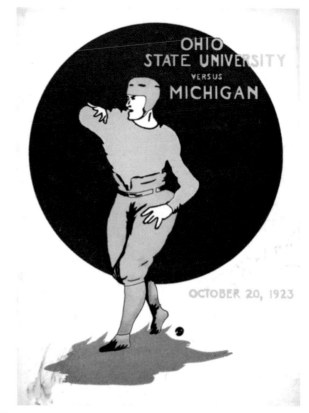

Coach Yost won his sixth national championship with the 1923 University of Michigan team, and the Wolverines won their second consecutive conference championship. Michigan was led by 1923 All-American center Jack Blott and team captain/halfback Harry Kipke. (BHL.)

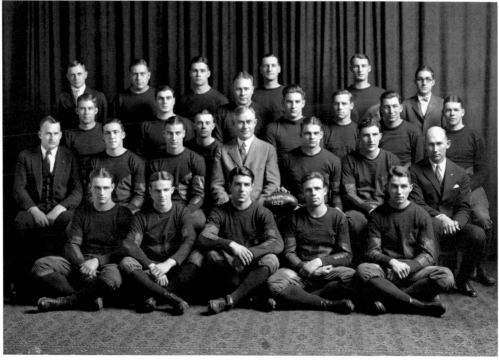

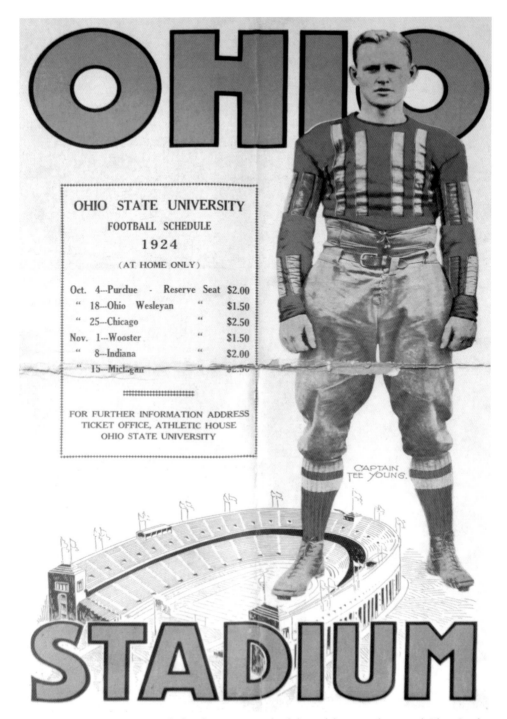

OHIO

OHIO STATE UNIVERSITY
FOOTBALL SCHEDULE
1924

(AT HOME ONLY)

Oct.	4---Purdue - Reserve Seat		$2.00
"	18---Ohio Wesleyan	"	$1.50
"	25---Chicago	"	$2.50
Nov.	1---Wooster	"	$1.50
"	8---Indiana	"	$2.00
"	15---Michigan	"	$2.50

FOR FURTHER INFORMATION ADDRESS
TICKET OFFICE, ATHLETIC HOUSE
OHIO STATE UNIVERSITY

CAPTAIN
TEE YOUNG.

STADIUM

This 1924 Ohio State poster includes the season's schedule and features the grand Ohio Stadium and Buckeye captain Francis "Tee" Young. The 1924 game was won by the Wolverines 16-6 in front of a capacity Columbus crowd of 70,000. This was also the first game in the series broadcast on radio, by WWJ Detroit, with announcer Ty Tyson behind the microphone. (VJ.)

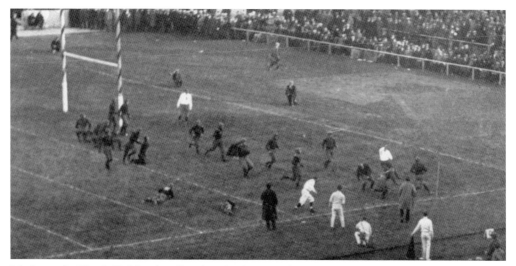

Michigan halfback Tod Rockwell rushes for short yardage near the goal line in the 1924 game. It led to a Michigan touchdown and a 7-6 lead. Rockwell later kicked a field goal and then scored a touchdown as he accounted for 10 of Michigan's 16 points. (*Michiganensian*, 1925.)

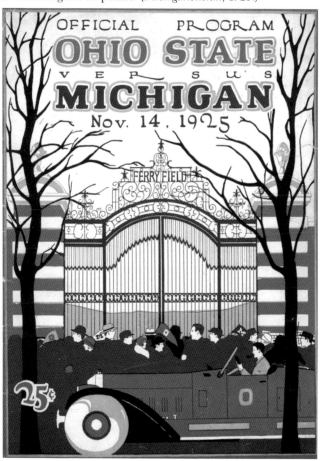

This is the program for the 1925 rivalry game. A capacity crowd of 47,000 at Ferry Field watched the Wolverines win the game 10-0 on November 14. Michigan was not scored upon all season, with the exception of three points given up to Northwestern in a rain-soaked game. The 3-2 loss, at Soldier Field in Chicago, was Michigan's only blemish in 1925. Fielding Yost called the 1925 football squad "the finest I ever coached." (Ken Magee collection.)

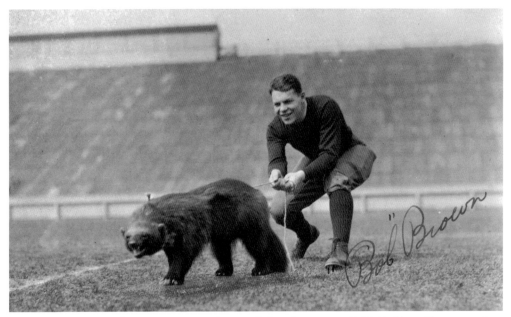

Michigan captain Bob Brown poses with a stuffed wolverine in 1925. Fielding Yost wanted to show off a live mascot, but he was only able to acquire this stuffed wolverine from the Hudson Bay Company in Canada. Eventually, Yost made a deal with the Detroit Zoo to parade two newly acquired wolverines, named Bennie and Biff, in a cage for the 1927 Michigan Stadium dedication game. Later, Yost realized that wolverines were too ferocious to maintain in captivity. Wolverine fans to this date have not supported the idea of creating a friendly mascot similar to Brutus the Buckeye. (BHL.)

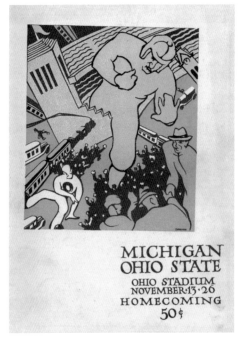

MICHIGAN
OHIO STATE
OHIO STADIUM
NOVEMBER·13·26
HOMECOMING
50¢

The cover of the game program for November 13, 1926, depicts the scene at Ohio Stadium for homecoming weekend in Columbus. This a fine example of the artwork used in the 1920s to make game programs attractive and valued as collector's items. From an artwork standpoint, it is similar to the 1925 program cover shown on the previous page depicting the scene in front of Ferry Field in Ann Arbor. (Ken Magee collection.)

Pictured is Ohio State halfback and team captain Marty Karow. He scored the first touchdown in the 1926 game for the Buckeyes. An outstanding football player, he earned All-American honors in 1926. (VJ.)

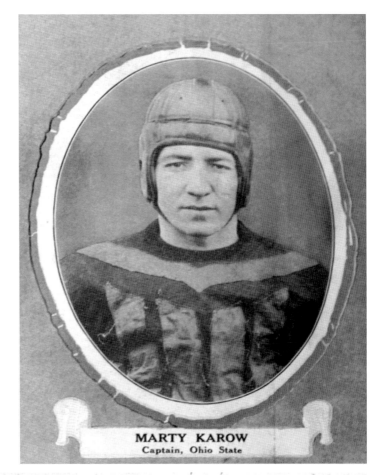

MARTY KAROW
Captain, Ohio State

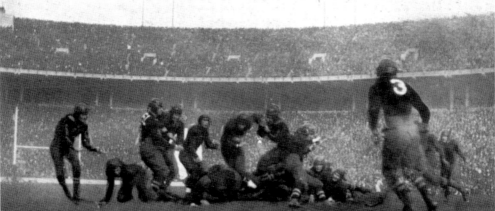

Pictured is action from the 1926 game, held in Ohio Stadium. With the conference championship on the line for both teams, Michigan won a close game, 17-16, behind the outstanding play of Benny Friedman and Bennie Oosterbaan. The Wolverines fell behind 10-0 and came back in the second half to win on Friedman's extra point. Michigan went on to capture its fourth Big Ten Conference championship in five years. (*Michiganensian*, 1927.)

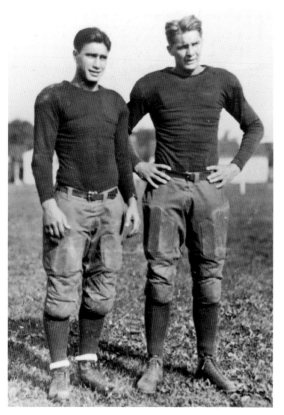

Michigan quarterback Benny Friedman (left) and end Bennie Oosterbaan (right) were named All-Americans in 1925 and 1926. They were known in sports history lore as 'Benny to Bennie" for their outstanding passing combination. Friedman was named the Big Ten most valuable player in 1926. (BHL.)

This 1950s All-American trading card depicts Benny Friedman. The quarterback was part of the legendary passing combination created by Coach Yost. Friedman was the 1926 team captain and a two-time All-American. After college, he had a very successful career in professional football and was an all-pro quarterback. He was inducted into the College Football Hall of Fame in 1954 and the Pro Football Hall of Fame in 2005. (Ken Magee collection.)

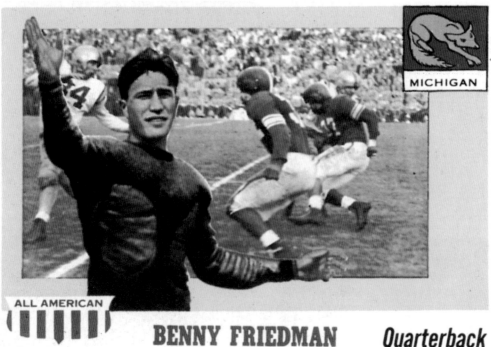

MICHIGAN

ALL AMERICAN

BENNY FRIEDMAN *Quarterback*

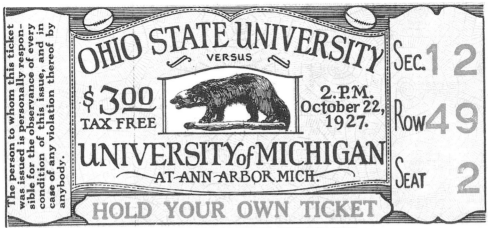

Shown here are the ticket and program for the October 22, 1927, dedication game for the newly constructed Michigan Stadium. There were 84,401 spectators on hand to witness the battle, including the governors of both Ohio and Michigan, who walked across the field with Fielding Yost and received a standing ovation from the crowd. Michigan went on to win the game, 21-0. Halfback Louis Gilbert scored three touchdowns on passes from All-American end and team captain Bennie Oosterbaan. (Both, Ken Magee collection.)

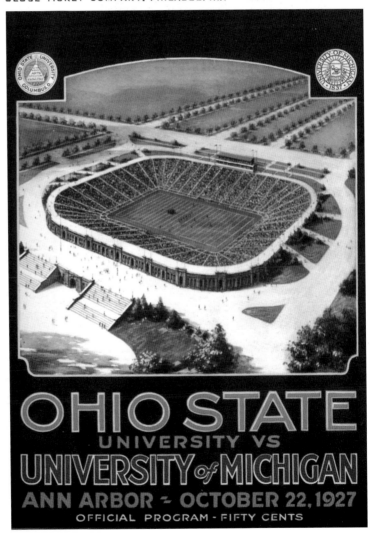

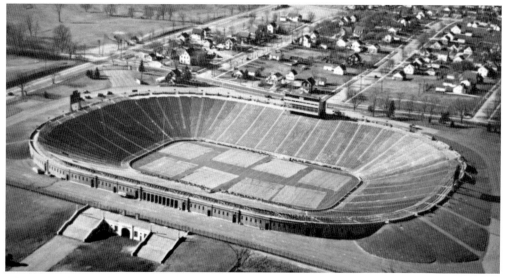

The newly constructed Michigan Stadium, completed in 1927, was the crowning moment for Fielding Yost, who envisioned this grand structure. A series of bonds were sold to raise funds for the stadium, which cost $950,000 to construct. It was designed to hold 72,000, but capacity was increased to 84,401 with the addition of wooden bleachers around the top rim of the stadium. (Ken Magee collection.)

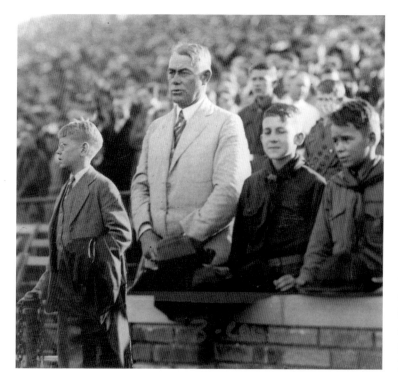

Athletic director Fielding Yost is flanked by Boy Scouts while in the stands of Michigan Stadium in 1927. For many years, it was common for Boy Scouts to be used as ushers at Michigan football games. (Ken Magee collection.)

MICHIGAN

ALL AMERICAN

BENNIE OOSTERBAAN *End*

This 1950s All-American trading card is of Bennie Oosterbaan. A three-time All-American, he is considered one of the greatest football players of all time. In 1969, the NCAA included Oosterbaan on the all-time list for the first 100 years of college football. He went on to become Michigan head coach from 1948 through 1958. An exceptional athlete, he was a nine-time letter winner who also played baseball and basketball, for which he was an All-American. His uniform no. 47 was retired by the University of Michigan. Oosterbaan was inducted into the College Football Hall of Fame in 1954. (Ken Magee collection.)

Michigan halfback Louis Gilbert runs with the football in the 1927 game. He made history by scoring three touchdowns against the Buckeyes in the Michigan Stadium dedication game. In a strange series of plays created by Michigan to baffle the Buckeyes, end Bennie Oosterbaan passed the football and connected with halfback Louis Gilbert on three different occasions for touchdowns. (BHL.)

This 1927 photograph captures game action. (*Michiganensian*, 1928.)

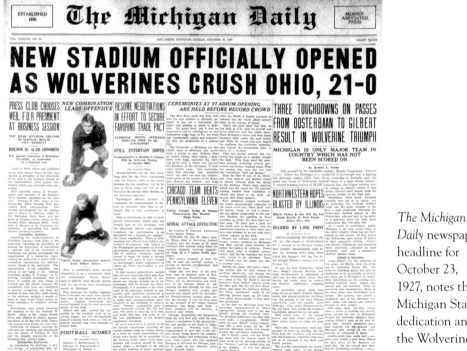

The Michigan Daily newspaper headline for October 23, 1927, notes the Michigan Stadium dedication and the Wolverines' victory over the Buckeyes, 21-0. (BHL.)

Shown here are the program and ticket for the October 20, 1928, game. The Buckeye faithful were finally rewarded with the team's first victory over Michigan in Ohio Stadium. The 72,439 spectators witnessed longtime coach John Wilce and the Buckeyes defeat the Wolverines 19-7 in Wilce's final season at Ohio State. This marked the first victory for the Buckeyes in the last seven attempts against Michigan. Wilce had been the head coach for the Buckeyes since 1913, the first year Ohio State was a member of the Big Ten. He was inducted into the College Football Hall of Fame in 1954. (Both, Ken Magee collection.)

On October 19, 1929, Ohio State defeated the Wolverines 7-0 with new head coach Sam Willaman. The game was played in front of a jam-packed, sold-out crowd of 85,088 at Michigan Stadium. Ohio State's only score was on a 22-yard pass to All-American end Wes Fesler. The Buckeye defense proved too tough for the Wolverines, who drove four times deep into Buckeyes territory and failed to score. The game ended with the Wolverines on the Buckeyes' 6-yard line. (Both, Ken Magee collection.)

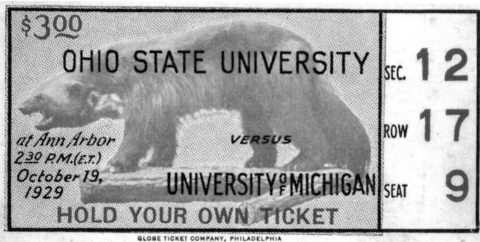

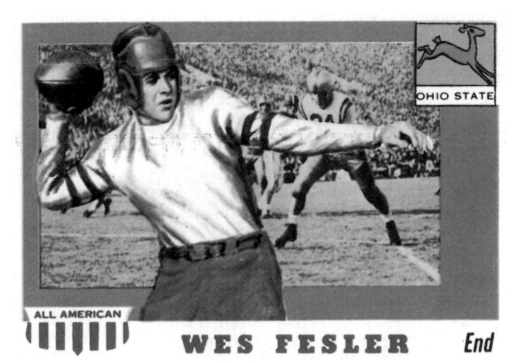

ALL AMERICAN

WES FESLER *End*

This 1950s All-American trading card depicts Wes Fesler. A three-time All-American end for Ohio State in 1928, 1929, and 1930, his overall record against Michigan was 2-1. He scored the winning touchdown against Michigan in 1929. An outstanding athlete, Fesler also played basketball and baseball for the Buckeyes. The Big Ten most valuable player in 1930, Fesler was inducted into the College Football Hall of Fame in 1954. (CB.)

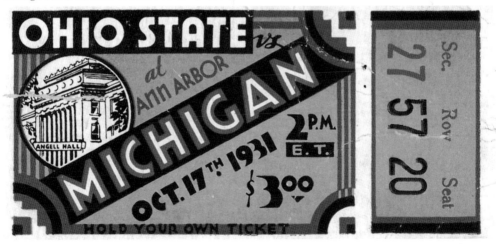

This is a ticket for the 1931 game, played on October 17 in Ann Arbor. Ohio State shocked the Wolverines by handing them a 20-7 defeat in front of 58,026 spectators. This was the only loss of the season for Michigan and ended a 16-game unbeaten streak. The Wolverines went on to tie for the conference title with Northwestern. Michigan, invited to play in the Rose Bowl, declined the offer due to conference regulations prohibiting postseason play. (Ken Magee collection.)

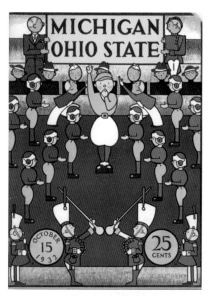

The 1932 game program, dated October 15, 1932, is shown here. The Wolverines shut out the Buckeyes 14-0 in front of 40,700 spectators at Ohio Stadium. The Buckeyes were inside the Wolverine 10-yard line five times, but a strong Michigan defense denied Ohio State each time. Michigan was led by All-Americans Harry Newman (quarterback), Chuck Bernard (center), and Ted Petoskey (end). (Ken Magee collection.)

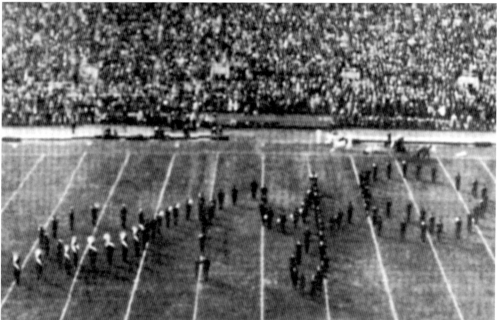

This vintage photograph shows the University of Michigan band forming the word "Ohio" in 1932. Michigan traveled with the marching band from Ann Arbor to Columbus that year. As a tribute to Ohio State, the Wolverine band created a formation that spelled the word "Ohio" in script, diagonally across the field. In 1936, Ohio State began their tradition with a new formation created by director Weigel. Cornet player John Brungart was the first to dot the "i." A year later, in 1937, Weigel turned to Glen Johnson (a sousaphone player) and shouted, "Hey, you! Switch places with the trumpet player in the dot." Since then, a sousaphone player has dotted the "i" over 800 times. Among other notables to dot the "i" are comedian Bob Hope, golfer Jack Nicklaus, astronaut John Glenn, boxing champ James Buster Douglas, and coach Woody Hayes. (BHL.)

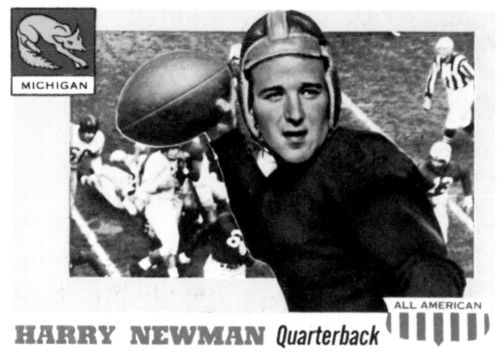

MICHIGAN

HARRY NEWMAN *Quarterback*

ALL AMERICAN

This 1950s All-American trading card is of Michigan quarterback Harry Newman. He guided the Wolverines to the national championship in 1932. That year, Newman was the winner of the Chicago Tribune Silver Football, awarded to the Big Ten's most valuable player, as well as the Douglas Fairbanks Trophy, the predecessor of the Heisman Trophy. Newman was inducted into the College Football Hall of Fame in 1975. (Ken Magee collection.)

The 1932 University of Michigan national champion team (8-0) earned coach Harry Kipke (second row, third from left) the first of two consecutive national championships. Led by captain Ivan Williamson (with football) and All-Americans Harry Newman (no. 46), Chuck Bernard (no. 27), and Ted Petoskey (no. 17), the Wolverines were an impressive defensive force, giving up only 13 points all season. (BHL.)

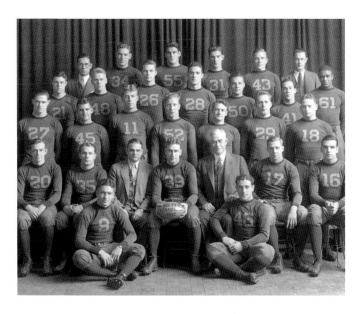

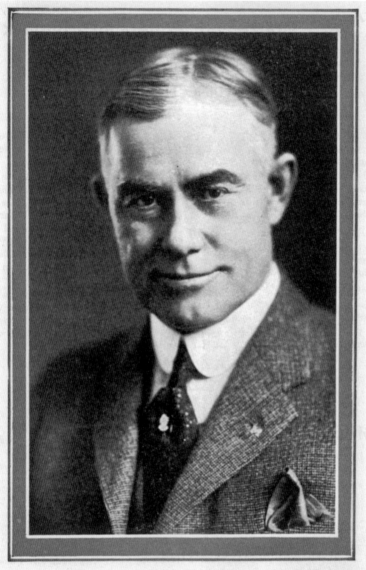

—*Photo by Rentschler*

"TODAY'S game is the 30th to be played by Ohio State and Michigan. Ever since Michigan's return to the Western Conference, these two teams have met each year and, I am sure, will continue to do so as long as the game of football exists. Ohio and Michigan are neighboring states. Their ideals of education and sportsmanship are identical.

"With such a record and with such a similarity of purpose and ideals, it would be strange indeed were not Ohio Michigan's 'most cherished opponent' ".

—FIELDING H. YOST
Director of Athletics
University of Michigan

This page from the 1933 game program features Fielding Yost. Michigan hosted Ohio State in the 30th meeting between the two teams. The praise Michigan athletic director Yost gives here was applicable to both schools. (Ken Magee collection.)

THE BIG GAME RIVALRY CONTINUES: 1919–1950

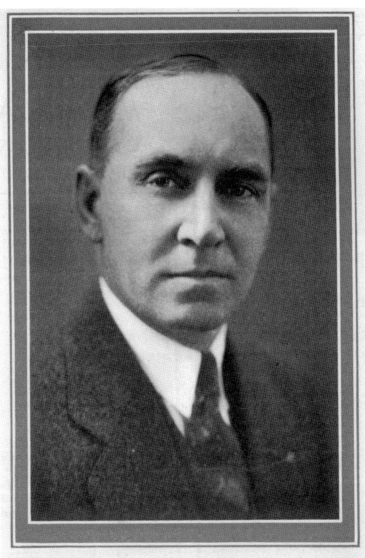

This page, also from the 1933 game program, shows Lynn St. John. Michigan hosted Ohio State that year. It is apparent that Ohio State athletic director St. John shared with Fielding Yost the same admiration for the schools and an appreciation for the storied rivalry. (Ken Magee collection.)

"TO THE University of Michigan—faculty, students, and alumni—greetings and good wishes!

"Michigan is Ohio's best loved and most cherished opponent. It is entirely fitting, therefore, for us to express to all Michigan men our congratulations and felicitations on Michigan's glorious record of splendid achievement. We honestly wish for you a great record for the present year. Ohio is always battling for her full share of victories and, therefore, for today we hope Ohio may win the game. That is the only exception we would register in the matter of our wishes for Michigan's success.

"In the Michigan-Ohio games, we have had the finest exemplification of true sportsmanship. No games anywhere have been superior in this respect and few games have equaled the standard set by our teams and their friendly, but rival supporters. That is something to be proud of and it is that feeling as much as the enjoyment of keen gridiron play that thrills us as the whistle blows today."

—L. W. St. John
Director of Athletics
The Ohio State University

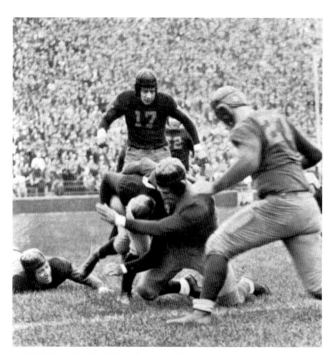

Ohio State quarterback Carl Cramer is tackled by Wolverines in the 1933 game. Two-time All-Americans Chuck Bernard (no. 27) and Ted Petoskey (no. 17) close in on the Buckeye player. Michigan went on to win the game 13-0 in front of 82,606 fans at Michigan Stadium, handing Ohio State its only loss of the season. (*Michiganensian*, 1934.)

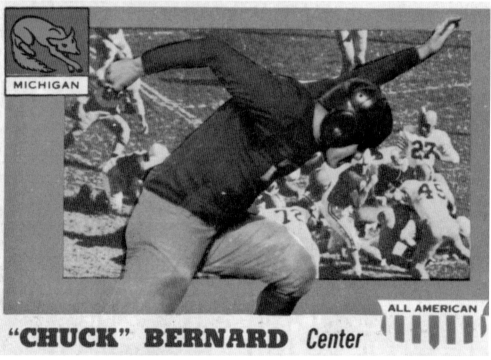

MICHIGAN

"CHUCK" BERNARD Center

ALL AMERICAN

This 1950s All-American trading card is of Chuck Bernard. Called the greatest college player in 1933 by professional coaches, two-time All-American center Bernard never lost a game he started. He is credited with securing the victory for Michigan in the 1933 game, intercepting a pass and stopping a Buckeye drive. His play set up the final score for Michigan. (Ken Magee collection.)

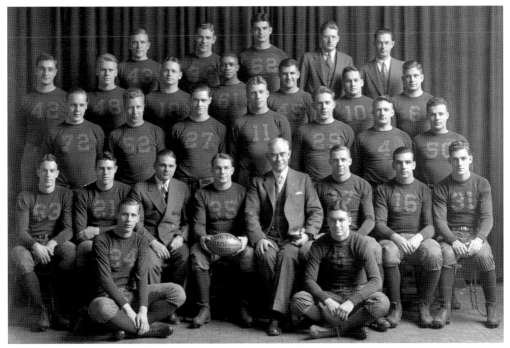

Michigan coach Harry Kipke secured his second consecutive national championship in 1933 while also tying for the Big Ten Conference championship with a 7-0-1 record. The powerful defensive unit gave up only 18 points in eight games. The only blemish on the perfect season was a 0-0 tie with conference co-champion Minnesota. The team was led by captain Stan Fay and All-Americans Chuck Bernard, Ted Petoskey, and Francis "Whitey" Wistert. In 1967, tackle Wistert was the first of three All-American Wistert brothers at Michigan to be inducted into the College Football of Fame. (BHL.)

This rare autographed trading card depicts Gerald R. Ford, from Grand Rapids, Michigan, who was known as Jerry Ford during his playing days for the Wolverines. A center, he had to wait his turn for two years during the 1932 and 1933 seasons, as he played behind two-time All-American Chuck Bernard. Ford was voted most valuable player of the 1934 team. After his playing days, he went to law school at Yale and then entered politics. He became the 38th president of the United States in 1974. His uniform no. 48 was retired by Michigan in 1994. He received the College Football Hall of Fame's highest honor, the Gold Medal, in 1972. (Ken Magee collection.)

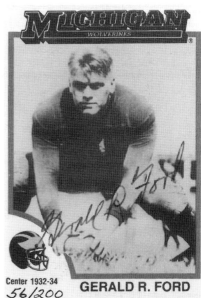

Center 1932-34 **GERALD R. FORD**
56/200

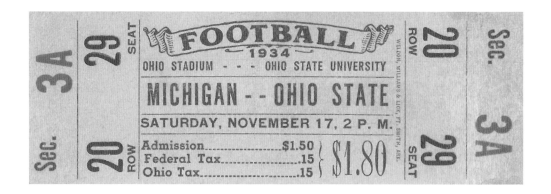

Shown above is a game ticket to the 1934 game, held on November 17, 1934. A scene from the game is seen below. The Wolverines traveled to Columbus to battle the Buckeyes and were soundly defeated, 34-0, in front of 62,893 spectators. The loss to Ohio State was the biggest the Wolverines had suffered in 42 years. It was also the first of four consecutive losses to the Buckeyes, who would outscore Michigan 114-0. This game started the Buckeye tradition of the "Gold Pants" award. (Above, Ken Magee collection; below, *Michiganensian*, 1935.)

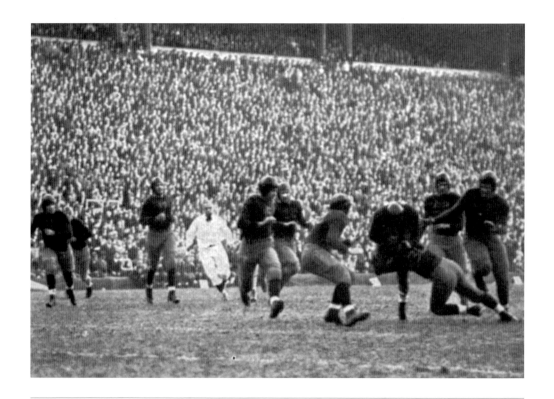

Following the disappointing loss in 1933 to Michigan, Ohio State decided to replace coach Sam Willaman. The school hired Francis Schmidt (pictured), who coached previously at Texas Christian University. When Schmidt was asked, "What about Michigan?" he replied, "Well, they put their pants on one leg at a time, the same as the rest of us." From this remark came the formation of the Gold Pants Club, where miniature gold pants charms were given to coaches and players who helped defeat Michigan. The tradition continues to this day. Schmidt was inducted into the College Football Hall of Fame in 1971. (KL.)

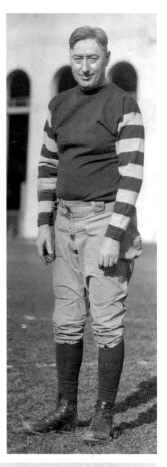

This is a ticket to the 1935 game, held on November 23, 1935. The Buckeyes traveled to Ann Arbor and continued their domination of the Wolverines, soundly defeating them 38-0 in front of 53,322 spectators at Michigan Stadium. The victory secured a share of the Big Ten Conference title for Ohio State with Minnesota. This game also started the tradition of the two teams playing each other on the last day of the Big Ten season, a tradition that continues to this day. (Ken Magee collection.)

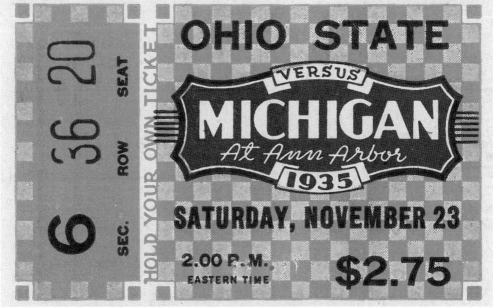

OHIO STATE
MICHIGAN

NOVEMBER
19··1938
OHIO STADIUM
TWENTY FIVE CENTS

HOMECOMING

The 1938 game program is shown at left. A scene from the game, held on November 19, 1938, is shown below. Michigan traveled to Columbus to play the Buckeyes in front of 64,413 spectators. The Wolverines won 18-0, ending a four-year drought against Ohio State. This season also saw the unveiling of Michigan's famous "winged helmets" by coach Fritz Crisler. This new helmet is being worn by halfback Paul Kromer, who is throwing the football while being hit by a Buckeye defender. (At left, Ken Magee collection; below, *Michiganensian*, 1939.)

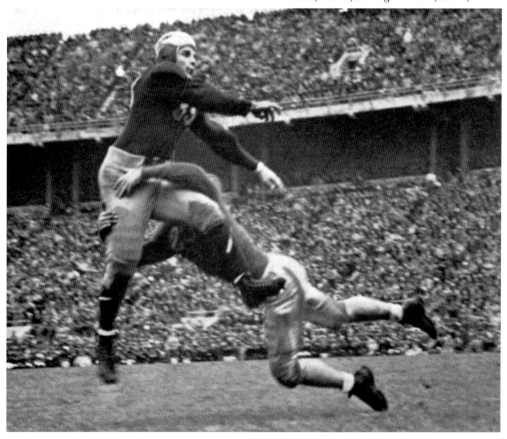

THE BIG GAME RIVALRY CONTINUES: 1919–1950

Depicted are advertisement items for Three Feathers Whiskey, featuring logos for each team, from the 1930s or 1940s. This is an example of how important this rivalry was; many merchandisers tried to capitalize on the rivalry. (Ken Magee collection.)

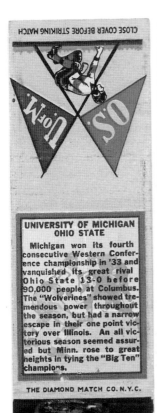

CLOSE COVER BEFORE STRIKING MATCH

UNIVERSITY OF MICHIGAN OHIO STATE

Michigan won its fourth consecutive Western Conference championship in '33 and vanquished its great rival Ohio State 13-0 before 90,000 people at Columbus. The "Wolverines" showed tremendous power throughout the season, but had a narrow escape in their one point victory over Illinois. An all victorious season seemed assured but Minn. rose to great heights in tying the "Big Ten" champions.

THE DIAMOND MATCH CO. N.Y.C.

CLOSE COVER BEFORE STRIKING MATCH

UNIVERSITY OF MICHIGAN OHIO STATE

Loss of one game during 1934 season was the only setback of a powerful Ohio State team which ranked second in the Western Conference. Ohio carried too many guns for her ancient rival, University of Michigan, and this annual classic resulted in a 34-0 victory for State.

THE DIAMOND MATCH CO. N.Y.C.

These are vintage matchbook covers from the 1930s commemorating the rivalry between the two schools. (Ken Magee collection.)

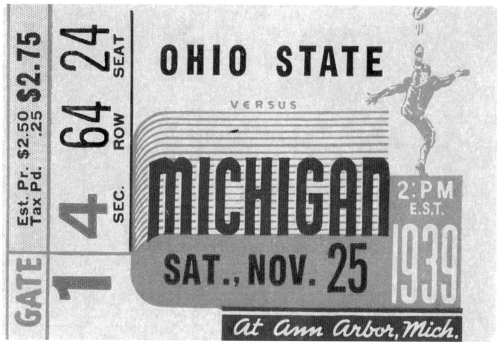

The 1939 game was played on November 25 in front of 78,815 spectators at Michigan Stadium. On this day, Michigan upset the favored Buckeyes 21-14. Ohio State jumped out to a 14-0 lead before Wolverine All-American, and the nation's leading scorer that year, Tom Harmon took charge. He accounted for two touchdowns, running for one and passing for another to teammate Forest Evashevski. The Wolverines won in the last minutes, when Harmon faked a field goal kick and holder Fred Trosko raced 24 yards for the game-winning touchdown. Ohio State still won the Big Ten Conference title that year with a 5-1 conference record. (Ken Magee collection.)

Michigan quarterback Forest Evashevski is seen catching a pass in the 1939 battle, which was won by the Wolverines in an upset over eventual conference champion Ohio State. Evashevski was known as a blocking quarterback for Michigan great Tom Harmon in their single-wing offense. (*Michiganensian*, 1940.)

Ohio State halfback Frank Zadworney crashes into the Michigan line during the 1939 battle in Ann Arbor. Big Ten Conference champion Ohio State was led by two-time All-American halfback Don Scott (killed in World War II) and All-American end Esco Sarkkinen, who became a longtime assistant coach for the Buckeyes. (*Michiganensian*, 1940.)

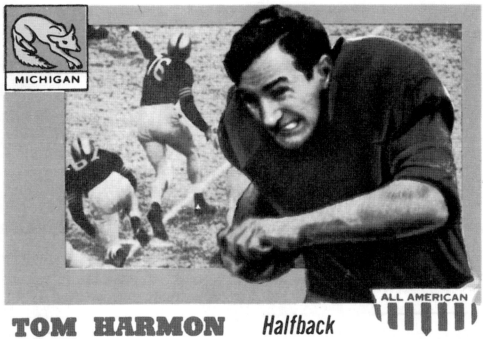

TOM HARMON *Halfback*

MICHIGAN

ALL AMERICAN

This 1950s All-American trading card depicts Tom Harmon. One of the greatest college football players in history, Michigan's Harmon won the Heisman Trophy in 1940 after being runner-up to Iowa's Nile Kinnick in 1939. Known as "Old 98" and "Harmon of Michigan," the two-time All-American was also the Big Ten most valuable player in 1940. Harmon's uniform no. 98 was retired by the University of Michigan, and he was inducted into the College Football Hall of Fame in 1954. (Ken Magee collection.)

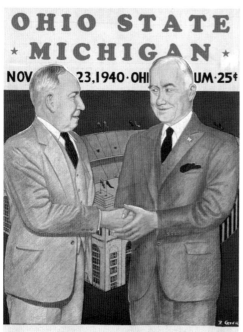

OHIO STATE ★ MICHIGAN ★

NOV. 23.1940·OHIO STADIUM·25¢

HOMECOMING

At left, the cover of the 1940 game program depicts Ohio State athletic director Lynn St. John (left) congratulating Michigan athletic director Fielding Yost on his pending retirement after four decades at the university. In the photograph below, Michigan great Tom Harmon runs with the ball. He cemented the Heisman Trophy win with his dominating play over the Buckeyes as Michigan won 40-0. On the rainy afternoon of November 23 in Ohio Stadium, 73,480 spectators watched in awe as Harmon scored three touchdowns, passed for two touchdowns, and kicked four conversions, personally scoring 22 points. He also punted three times for a 50-yard average. When Harmon was removed by Coach Crisler near the end of the game, he received a rare standing ovation from the Buckeye crowd. (At left, Ken Magee collection; below, *Michiganensian*, 1941.)

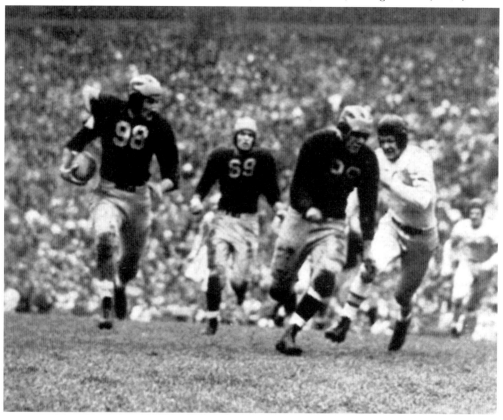

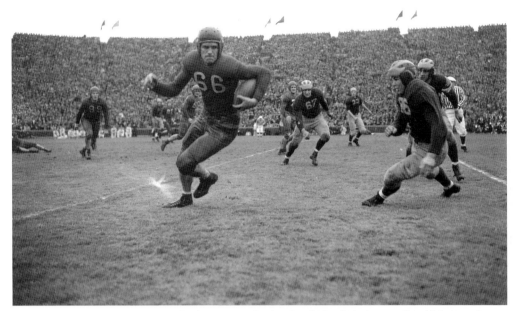

Buckeye halfback Thomas Kinkade runs with the football while being chased by Michigan All-American Bob Westfall in the 1941 game. The rivalry game was played in front of 84,581 spectators in a sold-out Michigan Stadium. Kinkade went on to score the second touchdown in the game for Ohio State. The contest ended in a 20-20 tie. (CP.)

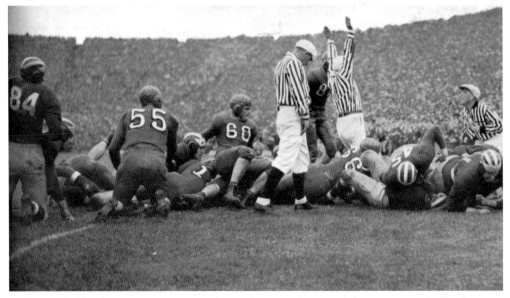

Michigan halfback Tom Kuzma scores the Wolverines' first touchdown against the Buckeyes in the 1941 game. Jack Graf, fullback for Ohio State, scored the Buckeyes' first touchdown in the game. He was the Big Ten most valuable player that year. (*Michiganensian*, 1942.)

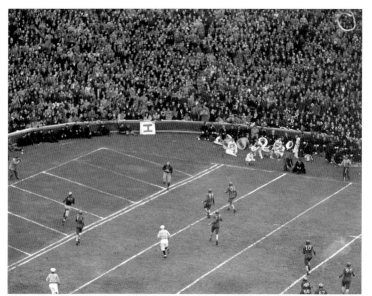

Michigan end Harlin Fraumann scores the Wolverines' second touchdown of the 1941 game on a pass from halfback Tom Kuzma. All-American fullback Bob Westfall would score Michigan's final and game-tying touchdown in the 20-20 draw. Westfall was inducted into the College Football Hall of Fame in 1987. (CP.)

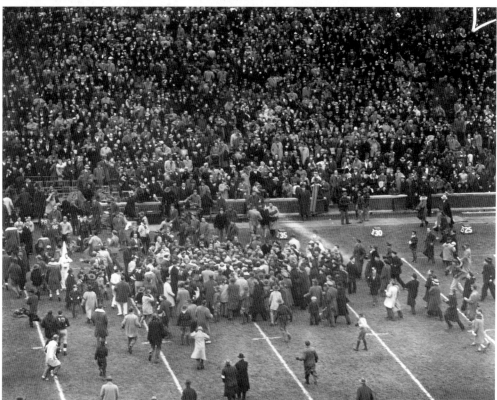

Shown here is an on-field brawl between the two teams after the game clock expired in the 1941 contest. The hard-fought battle resulted in a frustrating tie score. Tempers flared on the field, but the skirmish would pale in comparison to the attack on Pearl Harbor by Japan two weeks later, resulting in the entrance of the United States into World War II. (CP.)

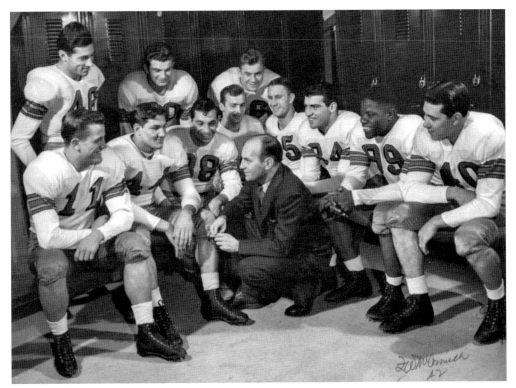

Legendary coach Paul Brown leads an Ohio State locker-room meeting in 1942. He was the first coach to win both an NCAA national championship (Ohio State, 1942) and an NFL championship (Cleveland Browns, 1950, 1954, 1955). For the Browns in 1946, he signed the following Buckeye players: placekicker Lou "The Toe" Groza, end Dante Lavelli, and tackle Bill Willis. They were inducted into the Pro Football Hall of Fame in 1974, 1975, and 1977, respectively; Coach Brown was inducted in 1967. (KL.)

Members of the backfield for the 1942 Ohio State national champion team pose in Ohio Stadium. They are, from left to right, Les Horvath (right halfback), Paul Sarringhaus (left halfback), Gene Fekete (fullback), and team captain George Lynn (quarterback). Ohio State defeated the Wolverines 21-7 in 1942. Sarringhaus threw three touchdown passes and Horvath caught two on a rainy and muddy day in Columbus. (KL.)

The 1942 Ohio State University national champion team poses here. The Buckeyes, with a 9-1 season record, vaulted into the final number-one position on the last weekend of the season, as previous number-one Boston College and number-two Georgia Tech both lost. Ohio State's only upset loss was to Wisconsin, led by legendary halfback Elroy "Crazy Legs" Hirsch; however, Ohio State won the Big Ten Conference title when Wisconsin was upset by Iowa in its next game. The Buckeyes won the conference title with a record of 5-1, besting Wisconsin's 4-1. (Jon Stevens collection.)

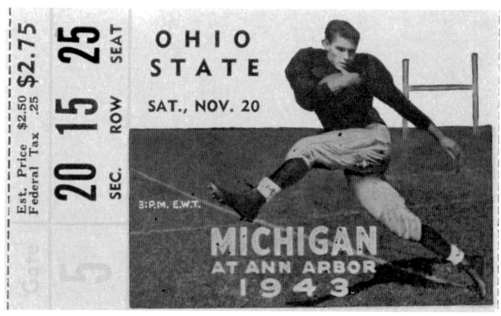

The 1943 game ticket depicts Michigan captain Paul White. The Wolverines would win over Ohio State 45-7 in Ann Arbor on November 20, securing the Big Ten Conference championship for the first time under Coach Fritz Crisler. Michigan's only blemish in 1943 was a 35-12 loss to national champion Notre Dame in Ann Arbor. (Ken Magee collection.)

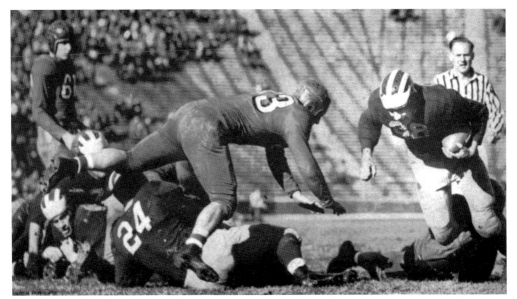

Michigan fullback Bob Wiese carries the football against the Buckeyes in 1943. Wiese was named the team most valuable player in 1943. The photograph shows a sparse crowd of 39,139 for this rivalry game due to World War II travel restrictions. (*Michiganensian*, 1944.)

Michigan coach Fritz Crisler is carried off the field after the Wolverines' victory in Ann Arbor in 1943. Not known at the time, this would be coach Paul Brown's last game for Ohio State. He would go on to coach the Great Lakes Naval Training team in 1944 and 1945 during World War II. Brown was replaced at Ohio State in 1944 and 1945 by assistant coach Carroll Widdoes. (*Michiganensian*, 1944.)

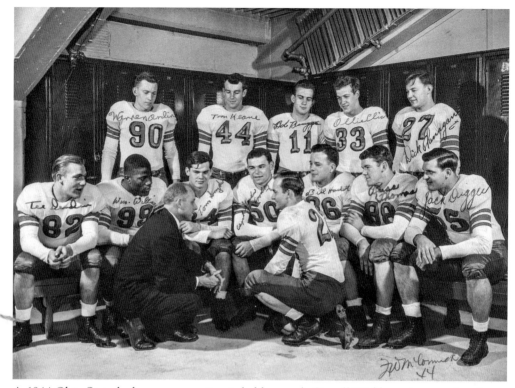

A 1944 Ohio State locker-room meeting is led by coach Carroll Widdoes. Among the players shown here are Les Horvath (no. 22), 1944 All-American, Heisman Trophy winner, and Big Ten most valuable player; Bill Willis (no. 99), 1943–1944 All-American tackle; Bill Hackett (no. 96), 1944 All-American guard; Jack Dugger (no. 55), 1944 All-American end; Warren Amling (no. 90), 1945–1946 All-American guard/tackle; and fullback Ollie Cline (no. 33), who was the 1945 Big Ten most valuable player. Willis's uniform number was retired by the Buckeyes in 2007. He was inducted into the College Football Hall of Fame in 1971 and the Pro Football Hall of Fame in 1977. Amling and Horvath were inducted into the College Football Hall of Fame in 1984 and 1969, respectively. (KL.)

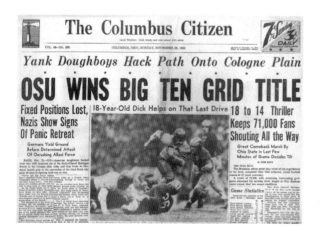

The Columbus Citizen of November 26, 1944, details Ohio State's narrow victory over Michigan, 18-12, in the final game. This capped an undefeated (9-0) season for the Buckeyes, who won the conference championship over Michigan. The Buckeyes would finish ranked number two behind a 9-0 Army team led by legendary backs Glenn Davis and Doc Blanchard. (The Columbus Dispatch.)

Shown here is the gold pants charm awarded in 1944 to Ohio State halfback and Heisman Trophy winner Les Horvath. The award is given to players and coaches who participate in a game in which rival Michigan is defeated. It was implemented as a Buckeye tradition by coach Francis Schmidt in 1934 and continues to this day. (KL.)

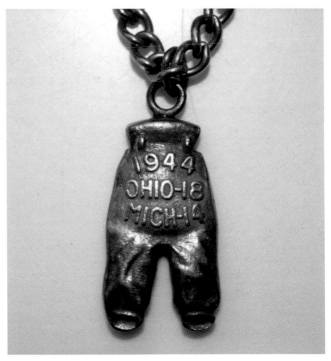

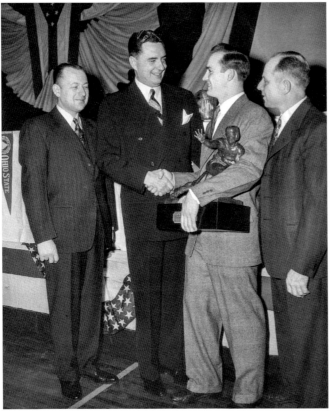

Ohio State legend Les Horvath (second from right) receives the 1944 Heisman Trophy. Horvath was the first Ohio State player to win this prestigious award. He competed with Army's Glenn Davis and Doc Blanchard for the honor. The next year, Blanchard won the Heisman Trophy, and Davis captured the honor in 1946. At far right is coach Carroll Widdoes, who was awarded the national Coach of the Year in 1944 over Army's Red Blaik. In 1946, Blaik would win this award. Horvath's uniform no. 22 was retired by Ohio State in 2001, and he was inducted into the College Football Hall of Fame in 1969. (KL.)

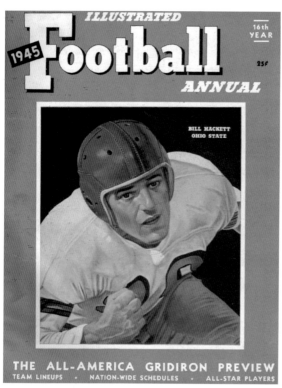

The 1945 *Illustrated Football Annual* season preview depicts Ohio State All-American Bill Hackett on the cover. Hackett, an outstanding All-American guard in 1944, was designated the Buckeyes' 1945 team captain. Unfortunately, injuries plagued him that season. His eldest son, Bill, would play for the Buckeyes from 1966 to 1968 as a middle guard under coach Woody Hayes. His youngest son, Jim, played at Michigan from 1974 to 1976 as center and linebacker under coach Bo Schembechler. Jim Hackett was appointed Michigan's athletic director in 2014. (Ken Magee collection.)

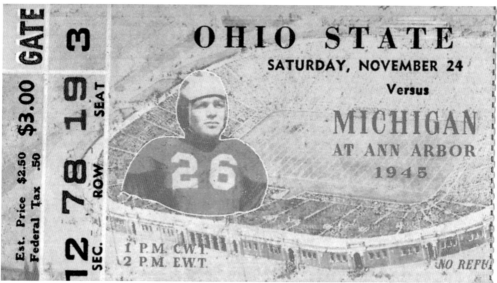

The ticket for the 1945 game, played on November 24, features Michigan captain Joe Ponsetto. The rivalry game that year, held at season's end in Ann Arbor, saw Michigan prevail 7-3 in a closely fought contest. Once again, a capacity crowd of 85,200 returned to Michigan Stadium, as the end of World War II saw the lifting of travel restrictions. Pete Elliott and Hank Fonde were instrumental in moving the Michigan offense down the field late in the fourth quarter, and Fonde scored the winning touchdown. (Ken Magee collection.)

The program for the November 23, 1946, game shows Ohio State athletic director Lynn St. John on the cover. He retired that year after serving as athletic director since 1912. It was homecoming weekend in Columbus, with 79,735 fans in attendance for the game. The Buckeye faithful sadly watched Michigan win in a rout, 58-6. Michigan halfback Bob Chappuis had a banner day, passing for three touchdowns and running for another. Ohio State coach Paul Bixler would be terminated after only one year as coach due to this loss to Michigan. (Ken Magee collection.)

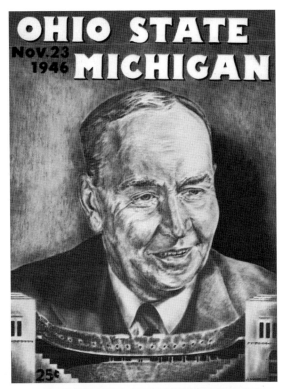

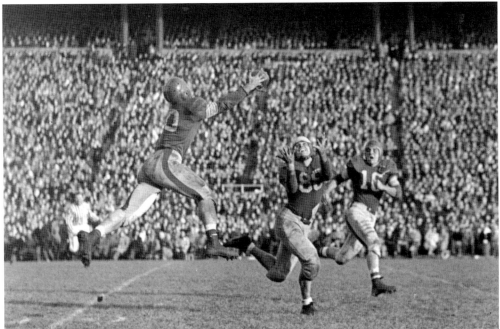

Michigan end Elmer Madar reaches for a pass in the Wolverines' 1946 victory in Columbus. He was Michigan's only All-American that year. Madar was particularly effective as a defensive end in Coach Crisler's two-platoon system. (CP.)

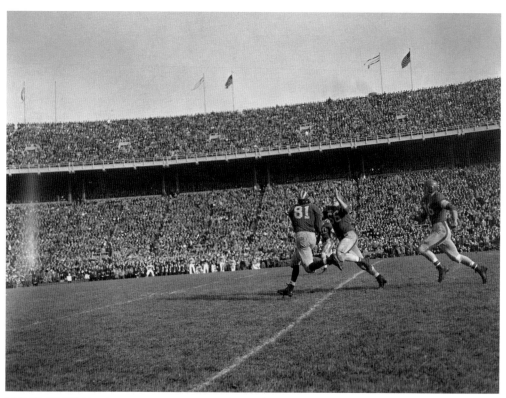

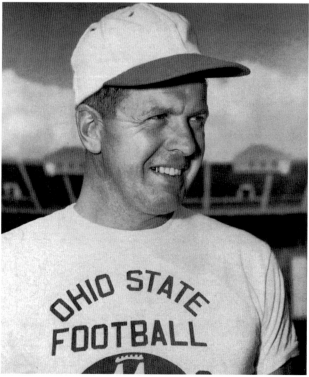

Wolverine end Bob Mann catches a pass in the 1946 game. He scored a touchdown on a pass from Bob Chappuis in the contest. That year, Mann would be the team leader in touchdowns scored, with five, on a team loaded with talented and returning World War II veterans. (CP.)

In 1947, Wes Fesler was chosen to return to his alma mater as head coach in an attempt to restore a winning program. His former Ohio State football teammate Dick Larkins, chosen as the new athletic director, hired Fesler. Larkins would hire Woody Hayes as head coach in 1951. (Ken Magee collection.)

The cover of the program for the November 22, 1947, game depicts Michigan captain Bruce Hilkene. That year's Wolverine team included a couple of interesting subplots. Quarterback Howard Yerges Jr. had received a football letter at Ohio State in 1943. He then transferred to Michigan and won four football letters from 1944 to 1947. His father, Howard Yerges Sr., had been a quarterback for Ohio State, playing in the same backfield as legendary Chic Harley on the 1916 and 1917 Big Ten Conference champion teams. Center J.T. White of the 1947 Michigan national champion team also played end on the 1942 Ohio State national champion team. He went against his brother Paul, a Michigan halfback, in 1942 and was his teammate in 1946. (Ken Magee collection.)

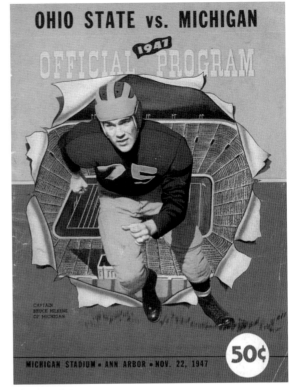

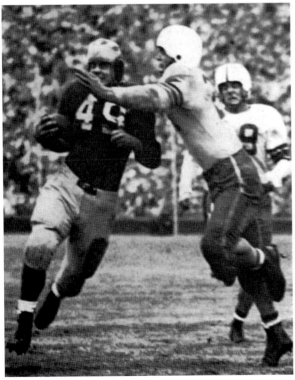

Here, Michigan All-American Bob Chappuis runs with the football in the 1947 contest. Michigan halfbacks Chappuis and Bump Elliott were All-Americans that year. The Wolverines beat Ohio State handily, 21-0, in Ann Arbor. The two halfbacks scored touchdowns in the game. Chappuis was the Heisman Trophy runner-up and the 1948 Rose Bowl most valuable player, while Elliott was the Big Ten most valuable player in 1947. The two were inducted into the College Football Hall of Fame in 1988 and 1989, respectively. (*Michiganensian*, 1948.)

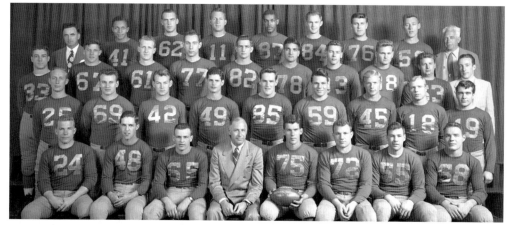

The 1947 University of Michigan national champion football team had an outstanding year (10-0), from both an offensive and a defensive standpoint, under coach Fritz Crisler's two-platoon system. After a convincing 1948 Rose Bowl victory over Southern California, 49-0, Michigan was voted number one over Notre Dame, which had been ranked number one after the regular season. Crisler would receive the national Coach of the Year award in 1947. (BHL.)

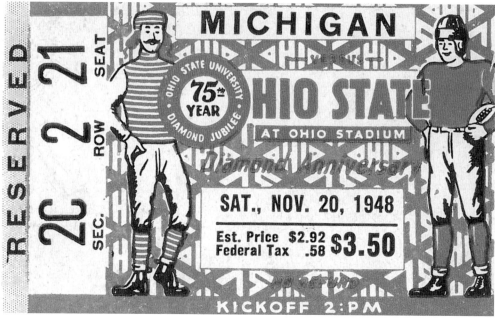

This ticket is for the November 20, 1948, contest. Michigan edged Ohio State 13-3 in Columbus in a hard-fought game to finish with a 9-0 season record. Michigan's All-Americans in 1948 were quarterback Pete Elliott (brother of Bump); end Dick Rifenburg, who had a team-leading eight receiving touchdowns; and tackle Alvin "Moose" Wistert, the third Wistert brother at Michigan to become an All-American. Pete Elliott was inducted into the College Football Hall of Fame in 1994. Albert and Alvin Wistert (brothers of Francis) were inducted into the College Football Hall of Fame in 1968 and 1981, respectively. The three Wistert brothers all wore uniform no. 11, which was retired by Michigan. (Ken Magee collection.)

This is a 1948 game-action photograph of Michigan halfback Chuck Ortmann (left). The 1948 season saw the emergence of sophomore halfbacks Ortmann and Leo Koceski as able replacements for Bob Chappuis and Bump Elliott. Michigan continued to use Fritz Crisler's two-platoon system effectively for its offense and defense. (*Michiganensian*, 1949.)

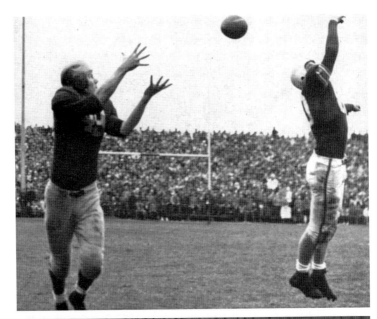

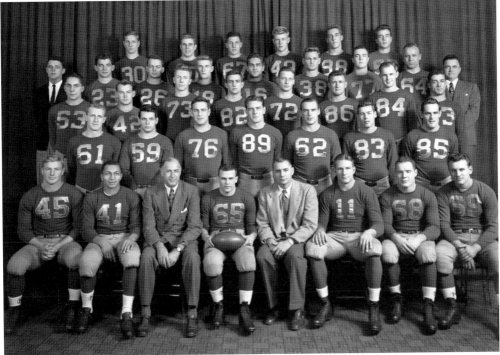

This is the team photograph of the 1948 University of Michigan national champions. Bennie Oosterbaan (first row, fourth from right) was appointed head coach of Michigan in 1948 following Fritz Crisler's retirement from coaching at the end of the 1947 season. The Michigan team had another outstanding season at 9-0, but under the Big Team Conference "no-repeat" rule, it did not play in the 1949 Rose Bowl. At the end of the 1948 regular season, Michigan was ranked number one, and Coach Oosterbaan received the national Coach of the Year award. (BHL.)

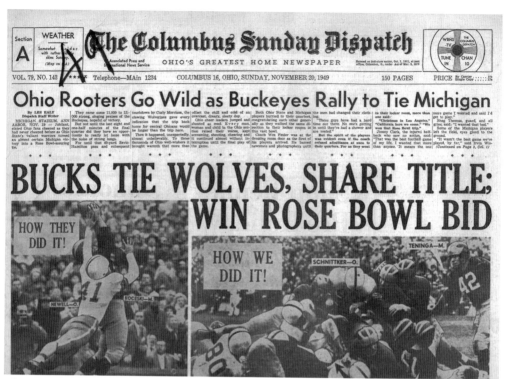

Section A — WEATHER: Somewhat colder with rather cloudy skies Sunday. (Map on A)

The Columbus Sunday Dispatch

OHIO'S GREATEST HOME NEWSPAPER

Associated Press and International News Service

Entered as 2nd-class matter, Oct. 1, 1911, at post office, Columbus, O., under Act of Mar. 3, 1879

VOL. 79, NO. 143 ★★★ Telephone—MAin 1234 COLUMBUS 16, OHIO, SUNDAY, NOVEMBER 20, 1949 150 PAGES PRICE By Carrier ... 15¢ Single Copy ... 15¢

WBNS-TV / THE COLUMBUS DISPATCH — TUNE IN 10 / CHAN 10

Ohio Rooters Go Wild as Buckeyes Rally to Tie Michigan

BUCKS TIE WOLVES, SHARE TITLE; WIN ROSE BOWL BID

The Columbus Sunday Dispatch headline for November 20, 1949, tells the story. A new attendance record of 97,239 was achieved in the recently enlarged Michigan Stadium. The game ended in a 7-7 tie, thus Michigan and Ohio State ended with identical conference first-place records. Coach Wes Fesler's Ohio State team was chosen to go to the Rose Bowl. Fullback Fred Morrison led Ohio State to a 17-14 victory over the University of California and was named the game's most valuable player. (*The Columbus Dispatch.*)

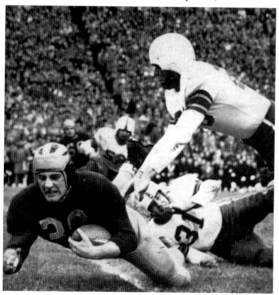

A 1949 game photograph depicts Michigan fullback Don Dufek diving with the ball. He would be the team's workhorse, leading in rushing yards and touchdowns in the 1949 and 1950 seasons. Dufek would be named the 1951 Rose Bowl most valuable player. His two sons, Don and Bill, became Michigan All-Americans under coach Bo Schembechler. (*Michiganensian*, 1950.)

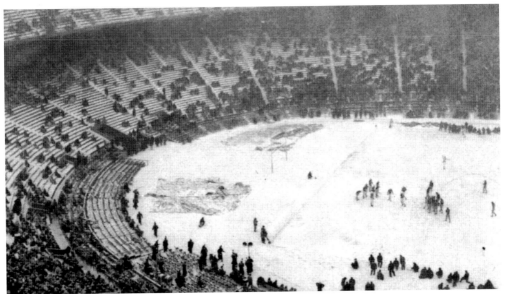

This postcard shows the 1950 game in snow-covered Ohio Stadium. Blizzard conditions hit Columbus and dumped about 18 inches of snow on the stadium prior to and during the game. Since both Michigan and Ohio State were in contention for the Big Ten Conference title, it was decided that the game would go on, dubbed the "Snow Bowl" or "Blizzard Bowl." The official attendance reflected 79,868 tickets sold, but only about 50,000 people actually attended the game. (Ken Magee collection.)

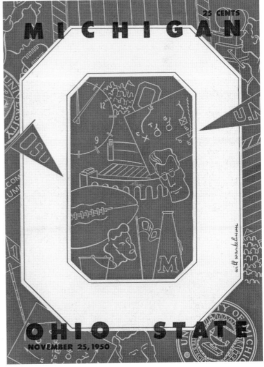

The program for the November 25, 1950, game is shown here. With the temperature near zero and winds at 25 to 30 miles per hour driving the snow in Columbus, the game quickly became a kicking contest. There were a combined 45 punts by Michigan's Chuck Ortmann and Ohio State's Vic Janowicz. There were five blocked punts, three of which led to all the scoring. Buckeye Bob Momsen's recovery of a blocked punt led to a Vic Janowicz field goal. Then, a blocked punt by Michigan yielded a two-point safety. Just before the end of the first half, Michigan's Tony Momsen (brother of Bob) blocked a punt and recovered it for the game-winning touchdown. Neither team scored in the second half, and the game ended with a Michigan victory, 9-3. (MA.)

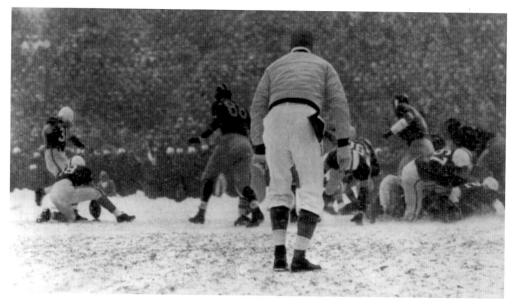

A 1950 game-action press photograph shows Ohio State halfback Vic Janowicz kicking a field goal. Notwithstanding Ohio State's upset loss to Michigan in the "Snow Bowl," Buckeye All-American Vic Janowicz would win the Heisman Trophy and Big Ten most valuable player award. His 27-yard field goal in the rivalry game under severe wind conditions was a most remarkable play. Janowicz's uniform no. 31 was retired by Ohio State in 2000, and he was inducted into the College Football Hall of Fame in 1976. (Ken Magee collection.)

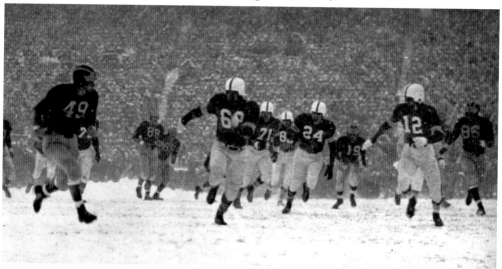

Michigan halfback Chuck Ortmann carries the ball in the 1950 contest. With Ortmann's passing abilities nullified in the severe weather conditions, his stellar punting provided Michigan with the victory and a trip to the 1951 Rose Bowl. Michigan's 14-6 Rose Bowl victory over the University of California was due in large part to Ortmann's passing abilities, combined with fullback Don Dufek's two rushing touchdowns. Dufek was named the game's most valuable player. Ortmann was inducted into the Rose Bowl Hall of Fame in 2009. (*Michiganensian*, 1951.)

4

A NEW BRAND OF WINNING FOOTBALL

1951–1968

Ohio State's Wes Fesler resigned as head football coach in January 1951 following the disappointing 1950 "Snow Bowl" loss. No one at the time could know that this resignation would open the door for one of college football's most famous coaches. Among the 40 candidates applying for the position was Paul Brown, who had coached the Buckeyes from 1941 to 1943, winning the national championship in 1942. Brown had also coached the successful Cleveland Browns professional football team—yet those credentials did not help Brown get the position. The announcement was made that Wayne Woodrow "Woody" Hayes was the new Ohio State football coach. Woody Hayes, born and raised in Ohio, played football and baseball for Denison University. After coaching high school football in Ohio, he enlisted for a five-year Navy tour, rising to the rank of lieutenant commander during World War II. He returned to his alma mater, Denison University, where he was head coach for three years. He then moved on to Miami University in Oxford, Ohio, for two years before landing the Ohio State position with a one-year contract for $12,500. He would remain as head coach for his entire 28-year career. Hayes won his first of five national championships in 1954; he also won the national championship in 1957, 1961, 1968, and 1970.

Hayes produced three Heisman Trophy winners: Howard Cassady (1955) and two-time winner Archie Griffin (1974 and 1975). His Ohio State teams went to 10 bowl games and won or shared the Big Ten Conference title 13 times. He produced 58 All-Americans and mentored many young players and coaches. His most famous protégé was both a player and a coach at Miami of Ohio and a coach at Ohio State. This young man, Glenn E. Schembechler, went on to be Hayes's archrival in coaching. But, Schembechler also remained a close friend in life. Simply put, Woody Hayes was and always will be a football legend. A three-time winner of the national Coach of the Year award, Woody Hayes was to college football what Vince Lombardi was to professional football. In a fitting tribute as a national figure in sports, when Coach Hayes passed away in 1987, his eulogy was given by former president Richard Nixon.

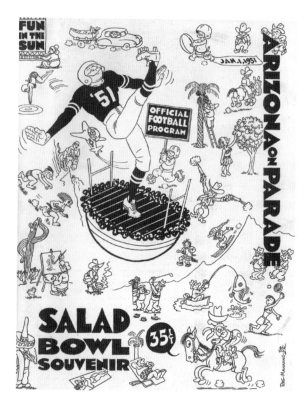

The player photographs (below) are from the January 1, 1951, Salad Bowl program. Six weeks before he was appointed head coach of Ohio State University, Wayne Woodrow "Woody" Hayes was the head coach for the Miami of Ohio University football team that traveled to Arizona to play in the now-defunct Salad Bowl. Miami of Ohio defeated Arizona State, 34-21. Playing for Hayes was a young tackle by the name of Bo Schembechler (far left, bottom row). (Both, Ken Magee collection.)

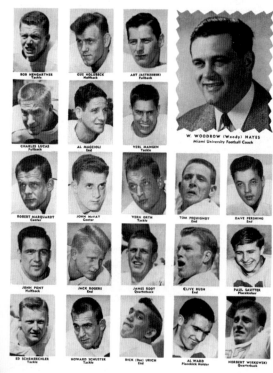

After Ohio State had four different men coach the team in the 1940s, very few Buckeye fans would have predicted that the school's new head coach, Woody Hayes, would remain in Columbus for the next 28 years. Ohio State lost a close game to Michigan in Ann Arbor, 7-0, in Hayes's first year. He quickly changed the competitive culture of this rivalry by never speaking the word "Michigan"; instead, he would only refer to it as "that school up north." Hayes went on to win 13 Big Ten Conference championships and five national championships. He was national Coach of the Year three times and was inducted into the College Football Hall of Fame in 1983. (Ken Magee collection.)

A 1951 game-action photograph shows Ohio State All-American halfback Vic Janowicz being tackled. This game, Woody Hayes's first in the rivalry, was played in Ann Arbor in front of 93,411 spectators. Michigan won the closely fought game, 7-0, but neither team came close to a Big Ten Conference title that year. Janowicz was unable to realize the same level of performance in 1951 as his Heisman Trophy and All-American performance results in 1950. This may have been due in part to Coach Hayes's style of offense, described as "three yards and a cloud of dust." (*Michiganensian*, 1952.)

This photograph, taken during the 1952 game, depicts Ohio State intercepting a pass intended for Michigan's All-American end Lowell Perry. Michigan traveled to Columbus, and on a wet Saturday afternoon the Buckeyes defeated the Wolverines 27-7 in front of 81,541 spectators. The victory over Michigan was the first in eight years for Ohio State, and it also marked the first win for Woody Hayes in the rivalry. (*Michiganensian*, 1953.)

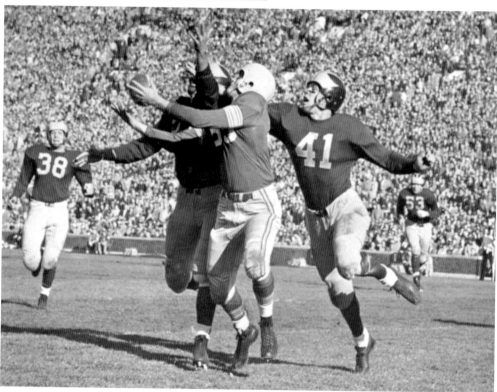

A 1953 game photograph depicts Michigan halfback Ted Kress (no. 41) defending against an Ohio State pass. A crowd of 87,048 in Ann Arbor watched the Wolverines defeat the Buckeyes 20-0 in their 50th meeting. Michigan gained a measure of revenge for the previous year's defeat in Columbus, with touchdowns by fullback Dick Balzhiser and halfbacks Tony Branoff and Dan Cline. Michigan successfully shut down the potent Ohio State offense of halfbacks Howard "Hopalong" Cassady and Bob Watkins. (*Michiganensian*, 1954.)

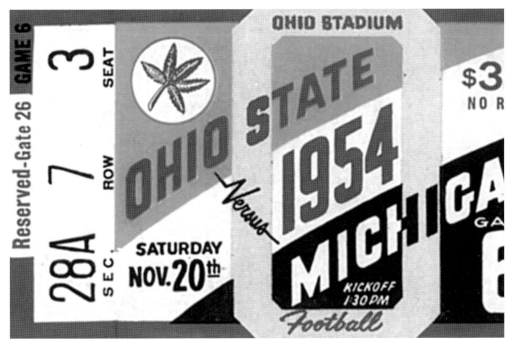

This is a ticket for the November 20, 1954, game, played in Columbus before 78,447 people. It was a battle for first place in the Big Ten Conference. Going into the contest, Ohio State was undefeated, and Michigan had only one conference loss. Ohio State prevailed 21-7. This game demonstrated that Hayes-coached Ohio State teams were becoming a dominant force in the conference. (Ken Magee collection.)

Posing here is the 1954 Ohio State University national champion football team. Ohio State's win over Michigan in 1954 resulted in a Big Ten Conference championship and an invitation to play in the Rose Bowl. The Buckeyes continued their winning streak, defeating Southern California in the 1955 Rose Bowl, 20-7. Ohio State's final record, 10-0, earned the team the national championship for 1954. (Jon Stevens collection.)

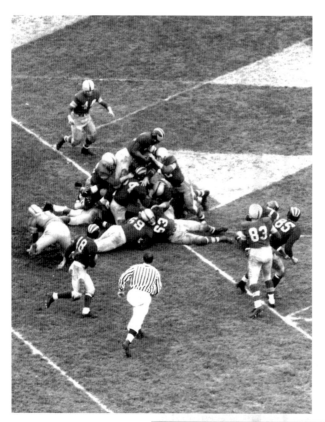

This photograph shows Ohio State's key goal-line stand in the 1954 game. With the score tied 7-7, Michigan mounted a forceful offensive drive, all the way to the Buckeye 4-yard line and a first down. In three plays, Michigan moved the ball to the one-foot line. As seen here, Michigan fullback Dave Hill was stopped on fourth down, six inches shy of a go-ahead touchdown. This was the turning point in the game. Ohio State All-American halfback Howard "Hopalong" Cassady had a 52-yard run to lead the Buckeyes 99 yards down the field for a go-ahead touchdown. An additional touchdown by Cassady finished the scoring. The Buckeyes won 21-7. (CP.)

This 1954 photograph depicts Ohio State fans utilizing placards to form a block "OSU." This attests to the high level of enthusiasm generated by the winning ways of Hayes-coached teams at Ohio State. (Ken Magee collection.)

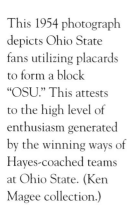

The Buckeyes would repeat in 1955 as Big Ten Conference champions. A mainstay on the Ohio State line from 1954 to 1956 was two-time All-American guard Jim Parker. He was also the 1956 Outland Trophy winner as the nation's top college lineman. Parker was inducted into the College Football Hall of Fame in 1974 and the Pro Football Hall of Fame in 1973. (Ken Magee collection.)

Ohio State halfback Howard "Hopalong" Cassady is seen in game action versus Michigan in 1955. An Ann Arbor crowd of 97,369 saw Ohio State blank a talented Michigan team 17-0. The Buckeyes that year were again led offensively by Cassady, including one touchdown scored. Cassady would become a two-time All-American and win the Heisman Trophy in 1955, and he also was named Big Ten most valuable player. His uniform no. 40 was retired by Ohio State in 2000, and he was inducted into the College Football Hall of Fame in 1979. (*Michiganensian*, 1956.)

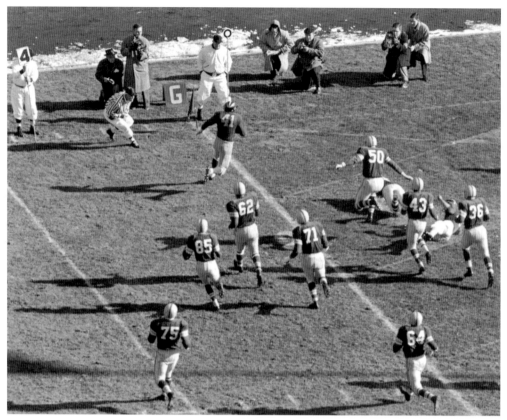

Michigan halfback Terry Barr crosses the goal line for a four-yard rushing touchdown in the 1956 game. Barr went on to score a second touchdown as the Wolverines shut out the Buckeyes in Columbus in front of 78,830 spectators by a score of 19-0. (*Michiganensian*, 1957.)

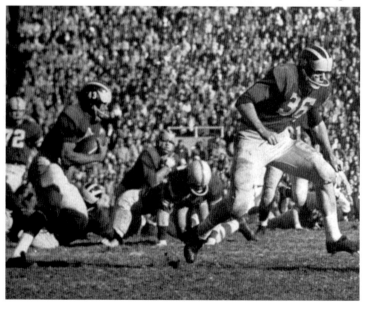

This is a 1956 game photograph of Michigan halfback Jim Pace running with the football. The Wolverines defeated the Buckeyes in Ohio Stadium. In 1957, Pace became an All-American and was selected as the Big Ten most valuable player. (*Michiganensian*, 1957.)

Michigan two-time All-American end Ron Kramer leaps high to make a tackle in the 1956 contest, held in Columbus. He was an outstanding athlete at Michigan in football, basketball, and track. His uniform no. 87 was retired by Michigan at the conclusion of his career in 1956. Kramer was inducted into the College Football Hall of Fame in 1978. (*Michiganensian*, 1957.)

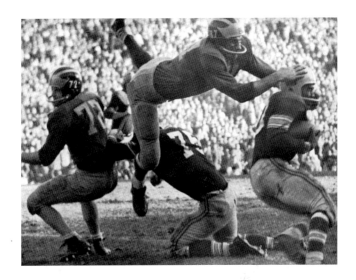

Jubilant Michigan fans celebrate on the field in Ohio Stadium following the 1956 contest after the Wolverines shut out the Buckeyes. The Michigan victory gained a measure of revenge, knocking the Buckeyes out of contention for a share of the Big Ten Conference title. (CP.)

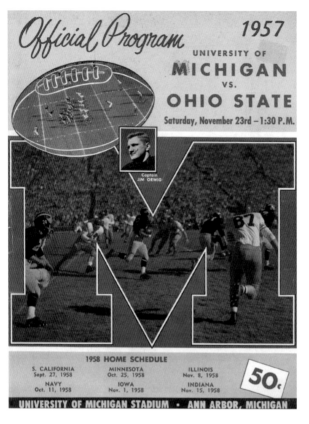

This is the program for the November 23, 1957, contest, played in Ann Arbor in front of a sellout crowd of 101,001. The Buckeyes would capture the conference championship and receive an invitation to the 1958 Rose Bowl by beating the Wolverines 31-14. Ohio State was led by All-American fullback Bob White, who successfully demonstrated Coach Hayes's "three yards and a cloud of dust" power offense. (Ken Magee collection.)

Pictured is the 1957 Ohio State University national champion football team. Following their victory over Michigan and a Big Ten title, the Buckeyes traveled to Pasadena for the 1958 Rose Bowl game, where they were successful in defeating Oregon 10-7. In doing so, Ohio State became the 1957 national champion. Coach Hayes would receive the national Coach of the Year award for the first time that season. (Jon Stevens collection.)

Shown above is a ticket for the November 22, 1958, game. Heavily favored Ohio State was in a battle with Michigan, trailing 14-10 before their All-American fullback Bob White, seen below, scored a third-quarter touchdown, which proved to be the winning points. Michigan quarterback Bob Ptacek set a conference record with 24 completed passes, but his effort was negated by six Michigan turnovers. The final turnover occurred on the Ohio State 4-yard line in the final minute of play, thus ending the Wolverines' chance for an upset. The Buckeyes won 20-14. (Above, Ken Magee collection; below, *Michiganensian*, 1959.)

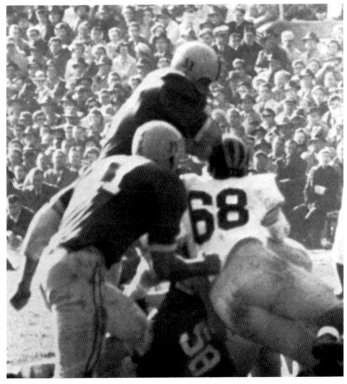

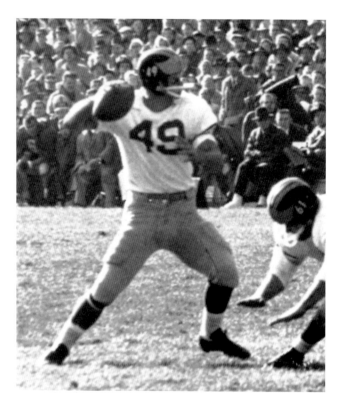

In the 1958 game, Michigan quarterback Bob Ptacek sets up to pass the football in what would be a record-setting day. Ptacek completed a conference-record 24 passes, and halfback Brad Myers had 12 receptions. These hefty stats for the maize and blue did not help the Wolverines plight. (*Michiganensian*, 1959.)

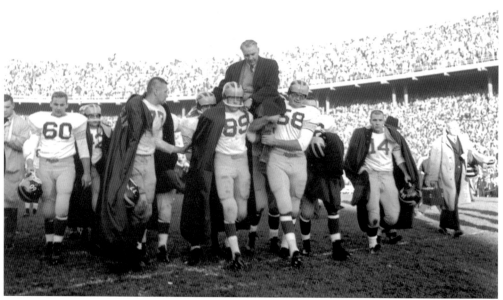

Michigan coach Bennie Oosterbaan is carried off the field by his players following the 1958 Michigan loss to Ohio State. This would be his last game as the Wolverine coach after 11 years, with an overall record of 63-33-4 and a record of 5-5-1 against Ohio State. (CP.)

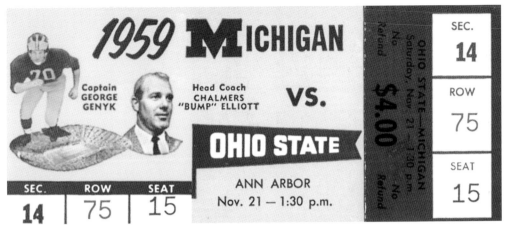

This November 21, 1959, game ticket depicts new head football coach Bump Elliott, who was an All-American halfback for the Wolverines and played on the 1947 national champion team. He came to Michigan after coaching at Iowa and serving as an assistant coach for Bennie Oosterbaan. The Wolverines were victorious in Elliott's first head-coaching battle against the Buckeyes, winning 23-14. (Ken Magee collection.)

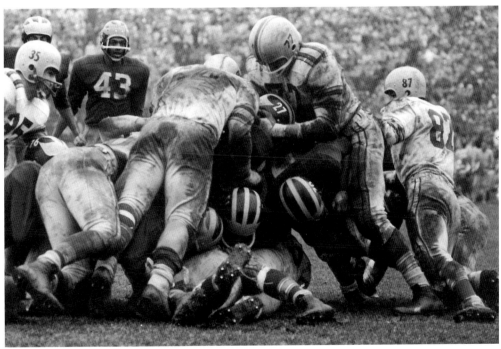

Michigan quarterback Stan Noskin plunges over the Ohio State goal line to score the Wolverines' first touchdown in the 1959 game. The hard-fought battle saw the Wolverines, and first-year head coach Bump Elliott, top the Buckeyes in Ann Arbor. (CP.)

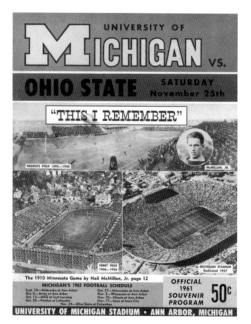

The November 25, 1961, game was played in Ann Arbor, with an attendance of 80,444. The Ohio State Buckeyes, led by two-time All-American fullback Bob Ferguson, completely dominated the Wolverines, 50-20. Ferguson, who scored four touchdowns in the rout, was the Maxwell Award winner and Heisman Trophy runner-up in 1961. He was inducted into the College Football Hall of Fame in 1996. (Ken Magee collection.)

Front row, left to right: Gene Fekete, junior varsity coach; Bo Schembechler, assistant junior varsity coach; Bill Arnsparger, tackle coach; Bill Hess, guard coach. Back row: Doyt Perry, backfield coach; Harry Strobel, defensive line coach; W. W. (Woody) Hayes, head coach. Esco Sarkkinen, end coach; Ernie Godfrey, assistant line coach.

Members of the 1961 Ohio State coaching staff pose for a photograph. Head coach Woody Hayes is in the second row, at center. Also depicted is a young coach named Bo Schembechler (first row, second from left), who was assistant junior varsity coach. Schembechler would be an assistant for Coach Hayes from 1958 to 1962 before moving to Miami of Ohio University, where he became head football coach at his alma mater. Ernie Godfrey (second row, far right) was the longest-serving Buckeyes assistant coach, for 33 years, from 1929 to 1961. He was inducted into the College Football Hall of Fame as a coach in 1972. (Ken Magee collection.)

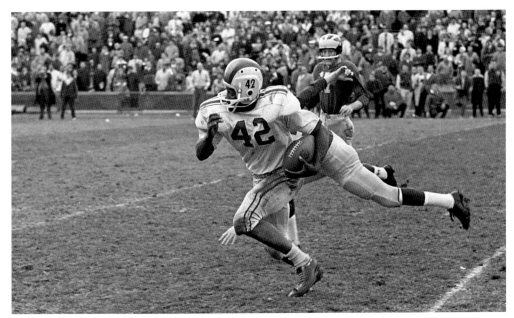

In the 1961 game, Ohio State star halfback Paul Warfield runs with the football. He scored a thrilling 69-yard touchdown in the Buckeyes' 50-20 victory against the Wolverines. Warfield was a key component to the success of the 1961 national champions. He went on to have a successful professional football career with the Cleveland Browns and Miami Dolphins, playing on the undefeated Miami team that capped a perfect season by winning Super Bowl VII in 1972. He was inducted into the Pro Football Hall of Fame in 1983. (CB.)

This is a team photograph of the 1961 Ohio State University national champions. Upon winning the Big Ten Conference championship, the Ohio State University Faculty Council unexpectedly voted not to send the football team to the 1962 Rose Bowl. Despite this situation, the team was selected number one nationally at the end of the season. (Jon Stevens collection.)

FORECAST
By U.S. Weather Bureau
Mild, windy, rain, low tonight
53. Saturday rain, windy,
colder, high 60.
See com 7:35, sea 3:16 Sat.
(Map and data on Page 5A)

Columbus Evening Dispatch

OHIO'S GREATEST HOME NEWSPAPER

VOL. 93, NO. 145 Phone—CApital 1-1234 COLUMBUS, OHIO 43216, FRIDAY, NOVEMBER 22, 1963 60 Pages ★★★★★ X Copyright, 1963 The Dispatch Printing Co. 7 Cents

FIVE STAR
★ ★ ★ ★ ★
STREET FINAL

JFK IS DEAD

Sniper Hits President In Motor Car

DALLAS, Tex. (P)—President John F. Kennedy, thirty-sixth President of the United States, was shot to death Friday by a hidden assassin armed with a high-powered rifle.

Kennedy, 46, lived about an hour after a sniper cut him down as his limousine left Downtown Dallas.

Automatically, the mantle of the presidency fell to Vice President Lyndon B. Johnson, a native Texan who had been riding two cars behind the Chief Executive.

There was no immediate word on when Johnson would take the oath of office.

Asst. Presidential Press Secretary Malcolm Kilduff said Johnson was not hit. The new President previously had been reported wounded.

Kennedy died at Parkland Hospital, where his bullet-pierced body had been taken in a frantic but futile effort to save his life.

Governor Is Also Wounded

Lying wounded at the same hospital was Governor John Connally of Texas, who was cut down by the same fusillade that ended the life of the youngest man ever elected to the presidency.

Connally and his wife had been riding with the President and Mrs. Kennedy.

The First Lady cradled her dying husband's blood-

PRESIDENT JOHN F. KENNEDY

JUST BEFORE KENNEDY SHOT—President John F. Kennedy, riding in motorcade approximately one minute before he was shot in Dallas. In the car riding with him are Mrs. Kennedy and Gov. and Mrs. John Connally of Texas.—(AP Wirephoto)

'Terrible' Sums Local Reaction To

BULLETINS

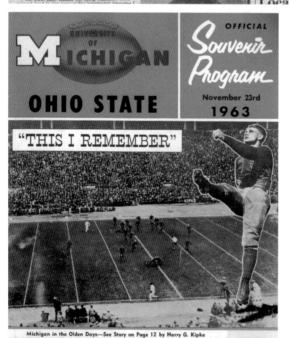

The 1963 game was scheduled for November 23, as indicated on the cover of that year's rivalry game program at left; however, the game was postponed until November 30 due to the assassination of Pres. John F. Kennedy. The photograph above shows the front page of the *Columbus Evening Dispatch* announcing the assassination. With the nation still mourning over the death of Kennedy, only 36,424 spectators showed up at Michigan Stadium to watch the 1963 game. Ohio State defeated the Wolverines 14-10. (Above, *The Columbus Dispatch*; at left, Ken Magee.)

Shown here is a ticket to the 1964 game. The contest was played on November 21 before 84,685 spectators in Columbus. Michigan won 10-0 behind the leadership of All-American quarterback Bob Timberlake and two-time All-American tackle Bill Yearby. Timberlake was named Big Ten most valuable player in 1964. After the victory, coach Bump Elliott was quoted, "This is my happiest moment in football." Michigan won the Big Ten Conference championship and went to the 1965 Rose Bowl, where it defeated the Oregon State Beavers, 34-7. (Ken Magee collection.)

In the 1964 game, Wolverine Rick Volk (left) battles for the football with Buckeye end Bob Stock. Volk, the nephew of Michigan All-American football legend Bob Chappuis, shared his uncle's uniform no. 49. Volk went on to earn All-American honors as a great defensive back in 1966. He had a successful professional football career, including earning a ring with the Baltimore Colts in Super Bowl V. (*Michiganensian*, 1965.)

MICHIGAN OHIO STATE

NOVEMBER 23, 1968 · OFFICIAL PROGRAM · FIFTY CENTS

This is the cover of the program for the 1968 game, held on November 23. In his last game as Michigan coach, Bump Elliott traveled with the Wolverines to Columbus to play for both the Big Ten Conference title and a chance for a trip to the Rose Bowl. It proved to be a laugher for the Ohio State faithful, as the Buckeyes destroyed the Wolverines 50-14. Late in the game, after Ohio State scored yet another touchdown, Coach Hayes elected to go for a two-point conversion. It failed, as Michigan held, but the Buckeyes' attempt to run up the score provided an incentive the following year, when first-year Michigan coach Bo Schembechler used it to motivate his players. Ohio State went on to win the national championship in 1968, defeating Southern California 27-16 in the 1969 Rose Bowl. (Ken Magee collection.)

This is a 1968 Ohio State University student season ticket. (Ken Magee collection.)

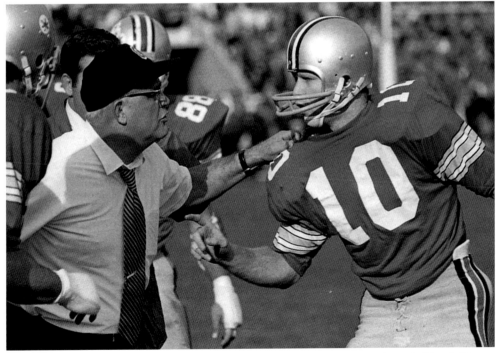

This 1968 game photograph depicts Ohio State quarterback Rex Kern and coach Woody Hayes. Kern won two national championships while at Ohio State (1968 and 1970) and was 2-1 against Michigan. He was named an All-American in 1969. A Heisman Trophy third-place finisher in 1969, Kern was inducted into the College Football Hall of Fame in 2007. (CB.)

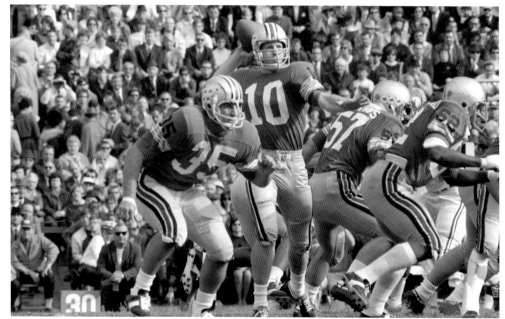

Seen in the 1968 game are Ohio State quarterback Rex Kern (no. 10) and fullback Jim Otis (no. 35). During this contest, Otis racked up 143 rushing yards and scored four touchdowns against the Wolverines. Kern added an additional two touchdowns. The Ohio State offense proved to be too much for Michigan and All-American halfback Ron Johnson, who scored two touchdowns; nevertheless, Johnson was the Big Ten most valuable player in 1968. He was inducted into the College Football Hall of Fame in 1992. The Buckeye helmets reflected a new tradition established by Coach Hayes in 1968, as seen here. Buckeye leaf decals were affixed to the helmets as awards for outstanding performance on the field. The tradition continues to this day. Kern and Otis were named All-Americans in 1969. (CB.)

Pictured is the 1968 Ohio State University national champion football team. Coach Hayes won his fourth national title, as the team went undefeated and won 10 consecutive games. The Buckeyes capped it off with a 27-16 victory over Southern California in the 1969 Rose Bowl. Hayes was named national Coach of the Year for a second time that season. (Jon Stevens collection.)

5

THE TEN YEAR WAR, PLUS 11 MORE YEARS OF BO

1969–1989

When Coach Bo Schembechler arrived in Ann Arbor in 1969, no one could have predicted that it would start what has been called the "Ten Year War"—Bo versus Woody. Hollywood could not have written a better script about the epic battles that pitted student against teacher. The similarities between these two men were profound. Schembechler, like Hayes, was born and raised in Ohio. He played football for Hayes while attending Miami of Ohio University and was also a baseball player. Schembechler was an assistant coach at Ohio State for Hayes in 1952, and again from 1958 to 1962, before Bo went on to become, like Woody, head coach at Miami University. And, like Woody, Bo left Miami University to become head coach at a Big Ten school, the University of Michigan.

The Ten Year War started in 1969, when one of the greatest teams in football history, the defending national champion Ohio State Buckeyes, traveled to Ann Arbor to battle Michigan and first-year head coach Schembechler. In what was considered one of the greatest upsets in college football history, the Wolverines defeated the Buckeyes 24-12. This set the tone for years to come. The two coaches battled for the conference championship eight times. At the end of the Ten Year War, when Hayes finished his coaching career, Bo had won five times and Woody four times. They battled to a historic tie in 1973. In 1979, future College Football Hall of Fame head coach Earle Bruce took over the Ohio State program. Bruce's record against Michigan was 5-4. Schembechler retired from coaching in 1989, and his overall record against Ohio State was 11-9-1. At Michigan, Coach Schembechler was 194-48, with five ties, and the Wolverines had won or shared the Big Ten title 13 times. He was named national Coach of the Year four times (1969, 1977, 1985, and 1989). Coach Schembechler went to 17 bowl games. Most important, he is credited with bringing the Wolverines back to a national platform as one of college football's elite programs, a status that had eluded Michigan since the late 1940s.

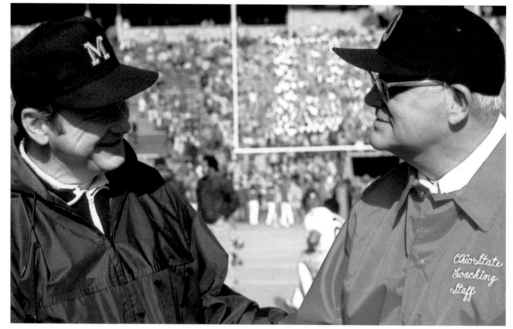

Here, two coaching legends, Bo Schembechler (left) and Woody Hayes, have a pregame conversation before one of their epic battles. Although fierce competitors on the gridiron, off the field they were close friends. Their "Ten Year War" is credited with defining the Michigan–Ohio State rivalry as one of the greatest in sports. (CB.)

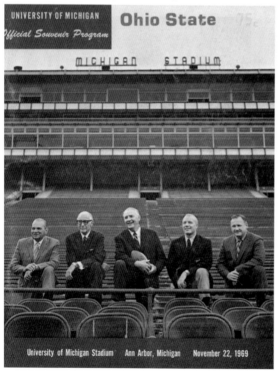

This is the program for the 1969 game, held on November 22. It is arguably the greatest Michigan victory in the history of the rivalry. The defending national champions and undefeated Buckeyes came to Ann Arbor ranked number one, with 22 consecutive wins, and were being compared to the NFL champion Minnesota Vikings. First-year coach Bo Schembechler, and his underdog Michigan squad, dueled fiercely against mentor Woody Hayes. Michigan forced six turnovers on the way to a 24-12 upset victory. Schembechler won his first national Coach of the Year award in 1969. (Ken Magee collection.)

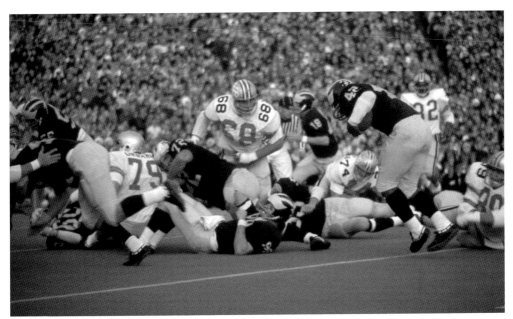

In the 1969 game, Wolverine Dan Dierdorf (no. 72) blocks for Billy Taylor (no. 42), while Buckeye Jim Stillwagon (no. 68) moves in for the tackle. Stillwagon was a two-time All-American (1969 and 1970) and an Outland Trophy winner (1970). Dierdorf was an All-American in 1970. Stillwagon and Dierdorf were inducted into the College Football Hall of Fame in 1991 and 2000, respectively. Dierdorf was inducted into the Pro Football Hall of Fame in 1996. (BHL.)

The Michigan Daily of November 24, 1969, declares the winner of that year's rivalry game. The historic battle featured many notable All-American and future College Football Hall of Fame players for both teams. For Michigan, they included end and captain Jim Mandich, safety Tom Curtis, tackle Dan Dierdorf, and guard Reggie McKenzie. For Ohio State, they included quarterback Rex Kern, defensive back Jack Tatum, and guard Jim Stillwagon. These players were inducted into the College Football Hall of Fame: Mandich (2004), Curtis (2005), Dierdorf (2000), McKenzie (2002), Kern (2007), Tatum (2004), and Stillwagon (1991). Kern finished third in the 1969 Heisman Trophy voting. (BHL.)

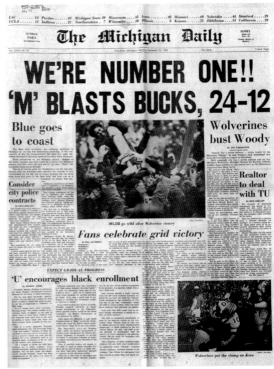

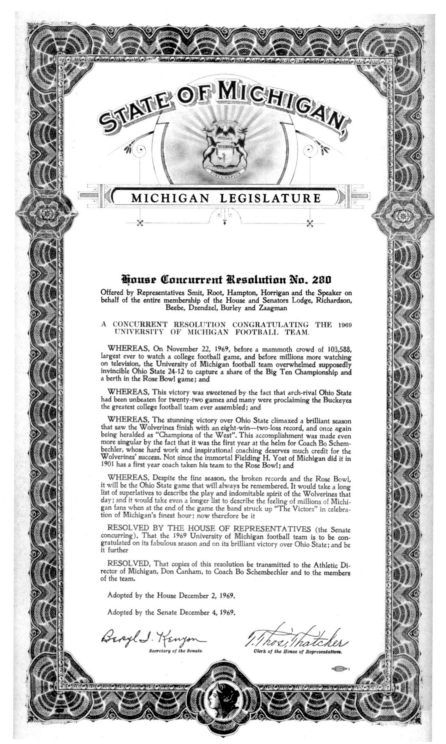

House Concurrent Resolution No. 280

Offered by Representatives Smit, Root, Hampton, Horrigan and the Speaker on behalf of the entire membership of the House and Senators Lodge, Richardson, Beebe, Dzendzel, Burley and Zaagman.

A CONCURRENT RESOLUTION CONGRATULATING THE 1969 UNIVERSITY OF MICHIGAN FOOTBALL TEAM.

WHEREAS, On November 22, 1969, before a mammoth crowd of 103,588, largest ever to watch a college football game, and before millions more watching on television, the University of Michigan football team overwhelmed supposedly invincible Ohio State 24-12 to capture a share of the Big Ten Championship and a berth in the Rose Bowl game; and

WHEREAS, This victory was sweetened by the fact that arch-rival Ohio State had been unbeaten for twenty-two games and many were proclaiming the Buckeyes the greatest college football team ever assembled; and

WHEREAS, The stunning victory over Ohio State climaxed a brilliant season that saw the Wolverines finish with an eight-win—two-loss record, and once again being heralded as "Champions of the West". This accomplishment was made even more singular by the fact that it was the first year at the helm for Coach Bo Schembechler, whose hard work and inspirational coaching deserves much credit for the Wolverines' success. Not since the immortal Fielding H. Yost of Michigan did it in 1901 has a first year coach taken his team to the Rose Bowl; and

WHEREAS, Despite the fine season, the broken records and the Rose Bowl, it will be the Ohio State game that will always be remembered. It would take a long list of superlatives to describe the play and indomitable spirit of the Wolverines that day; and it would take even a longer list to describe the feeling of millions of Michigan fans when at the end of the game the band struck up "The Victors" in celebration of Michigan's finest hour; now therefore be it

RESOLVED BY THE HOUSE OF REPRESENTATIVES (the Senate concurring), That the 1969 University of Michigan football team is to be congratulated on its fabulous season and on its brilliant victory over Ohio State; and be it further

RESOLVED, That copies of this resolution be transmitted to the Athletic Director of Michigan, Don Canham, to Coach Bo Schembechler and to the members of the team.

Adopted by the House December 2, 1969.

Adopted by the Senate December 4, 1969.

Beryl I. Kenyon
Secretary of the Senate

T. Thos. Thatcher
Clerk of the House of Representatives.

The Michigan House of Representatives passed Concurrent Resolution No. 280, congratulating the 1969 University of Michigan football team for its achievements. (JP.)

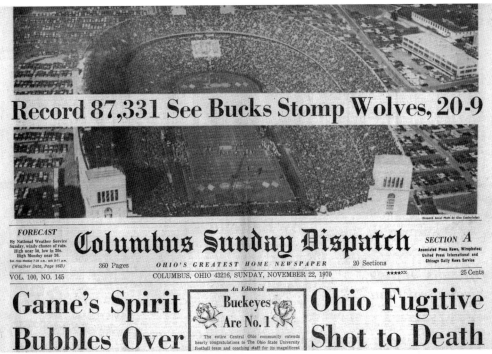

FORECAST
By National Weather Service
Sunday, windy chance of rain.
High near 50, low in 20s.
High Monday near 38.
Sun rises Monday 7-25 a.m.; sets 5-11 p.m.
(Weather Data, Page 86B)

Columbus Sunday Dispatch

SECTION A

Associated Press News, Wirephotos;
United Press International and
Chicago Daily News Service

360 Pages *OHIO'S GREATEST HOME NEWSPAPER* 20 Sections

VOL. 100, NO. 145 COLUMBUS, OHIO 43216, SUNDAY, NOVEMBER 22, 1970 ★★★★XX 25 Cents

Game's Spirit Bubbles Over

An Editorial

Buckeyes Are No. 1

The entire Central Ohio community extends hearty congratulations to The Ohio State University football team and coaching staff for its magnificent

Ohio Fugitive Shot to Death

This is *The Columbus Sunday Dispatch* for November 22, 1970. Both teams were undefeated heading into the final game of the regular season. The Buckeyes, led by All-American Rex Kern, defeated the Wolverines 20-9 in front of 87,331 fans in Columbus. As impressive as the Buckeye offense was, the big difference was Ohio's defense, which held the Wolverines to only 37 yards rushing and a total offense of just 155 yards. (*The Columbus Dispatch*.)

This is a photograph of the 1970 Ohio State University national champion football team, which included seven All-Americans. They vowed to avenge the previous year's upset loss to Michigan, which knocked the Buckeyes out of contention for a second consecutive national championship. Ohio State, upon beating Michigan in 1970, was selected number one nationally, notwithstanding its subsequent upset loss to Stanford in the 1971 Rose Bowl. The Buckeyes were true to their vow, winning a second national championship in three years. (Jon Stevens collection.)

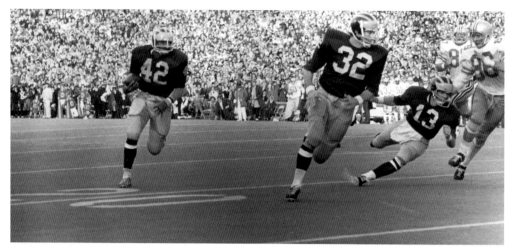

Michigan All-American halfback Billy Taylor carries the ball in the 1971 matchup in Ann Arbor. Taylor scored the game-winning touchdown with two minutes left in front of 104,016 spectators. His 21-yard run was made possible by a key block by Michigan fullback Fritz Seyfreth (no. 32). Legendary announcer Bob Ufer screamed over the airways a repetitive "Touchdown Billy Taylor! Touchdown Billy Taylor!" The Wolverines were 1971 Big Ten Conference champions, going 11-0. In the 1972 Rose Bowl, they were upset by Stanford 13-12. (BHL-BK.)

This is a ticket to the 1973 rivalry game, held on November 24. Both teams were undefeated: the Buckeyes were ranked number one, and the Wolverines were number four. Michigan placekicker Mike Lantry, who had helped the Wolverines tie the game earlier, narrowly missed two attempted field goals of 58 and 44 yards, respectively. The game ended in a 10-10 tie, and the teams also tied for the conference title. The conference athletic directors voted 6-4 to send the Buckeyes to the 1974 Rose Bowl, where they defeated Southern California 42-21. (Ken Magee collection.)

In the 1973 game, Michigan All-American defensive back Dave Brown (no. 6) awaits Ohio State All-American halfback Archie Griffin (no. 45) after he receives the ball from quarterback Cornelius Greene (no. 7). Griffin would rush for 163 yards on 30 carries in the epic battle, which ended in a 10-10 tie. Also prominent in this game was Buckeye tackle John Hicks, Outland Trophy winner and Heisman Trophy runner-up in 1973. Griffin would go on to win the Heisman Trophy twice, in 1974 and 1975. Players on the field that day who were later inducted into the College Football Hall of Fame were Griffin (1986), Hicks (2001), and Brown (2007). (CB.)

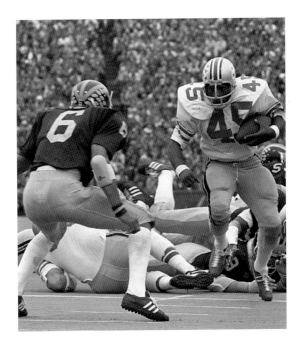

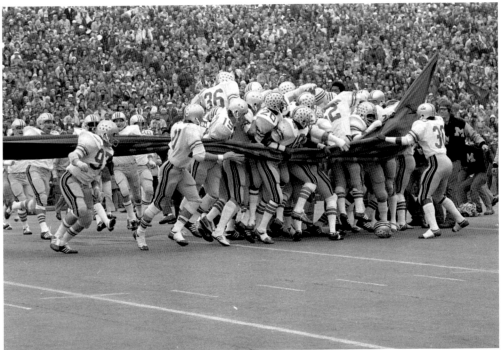

At every game in Michigan Stadium, it is customary for both teams to run onto the field from the tunnel. In the 1973 game, Ohio State coach Woody Hayes tried some psychological warfare. He had his squad run under and tear down the M-Club banner at midfield, which is reserved for the Wolverines. This act so incensed coach Bo Schembechler and his players that it might have generated a counterreaction. The Wolverines tied the favored Buckeyes that day, 10-10. (BHL.)

Woody Hayes stands on the sideline during the 1975 game. For the seventh time in eight years, the Buckeyes and Wolverines squared off to determine the Big Ten Conference championship. The winner of the game would also be the 1976 Rose Bowl representative for the Big Ten. The Buckeyes were ranked number one heading into the game. Michigan fought hard to the end before giving up two late touchdowns. Behind Buckeye fullback Pete Johnson's three touchdowns, Ohio State won 21-14. Ohio State quarterback Cornelius Greene was the Big Ten most valuable player in 1975. The Buckeyes returned to the 1976 Rose Bowl for the fourth year in a row but lost in an upset to UCLA, 23-10. (CB.)

The cover of this 1975 NCAA football guide depicts Ohio State All-American and Heisman Trophy winner Archie Griffin. Halfback Griffin went on to win the Heisman Trophy again in 1975, becoming the only player to win the Heisman Trophy twice. Griffin was the Big Ten most valuable player in 1973 and 1974. The Ohio State halfback was also a two-time All-American, and his uniform no. 45 was retired by Ohio State in 1999. He was inducted into the College Football Hall of Fame in 1986. (Ken Magee collection.)

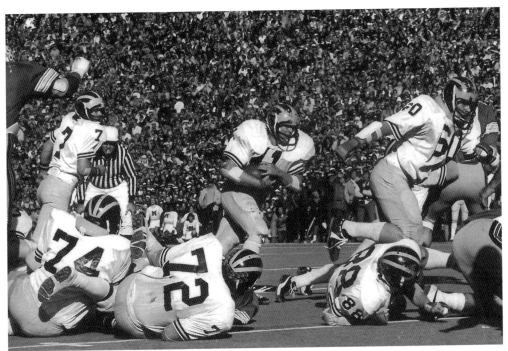

Michigan All-American halfback Rob Lytle (no. 41) takes a handoff from quarterback Rick Leach (no. 7) during the 1976 battle in Columbus. The Wolverines blanked the Buckeyes 22-0 in front of 88,250 spectators behind Lytle's 165 rushing yards and one touchdown. Fullback Russell Davis scored two touchdowns. One of the greatest athletes in Wolverine history, option quarterback Leach went on to become an All-American in 1978 and later played professional baseball. Both Lytle and Leach finished third in the Heisman Trophy voting and were the Big Ten most valuable players in 1976 and 1978, respectively. Lytle was inducted into the College Football Hall of Fame in 2015. Michigan, the co-conference Big Ten champion with Ohio State, went to the 1977 Rose Bowl, losing to Southern California, 14-6. (CP.)

Woody Hayes's final season with the Buckeyes was in 1978. In his final game against Michigan, the Buckeyes were defeated in Columbus 14-3 in front of 88,358 spectators. All-American Rick Leach threw for two touchdowns, and coach Bo Schembechler's high-powered offense outgained Ohio State by a two-to-one margin. Hayes ended one of the greatest coaching careers in college football history with an overall 205-61-10 record at Ohio State. In the Ten Year War with his pupil, Bo Schembechler, Hayes was 4-5-1. Overall against Michigan, Hayes was 16-11-1. (Ken Magee collection.)

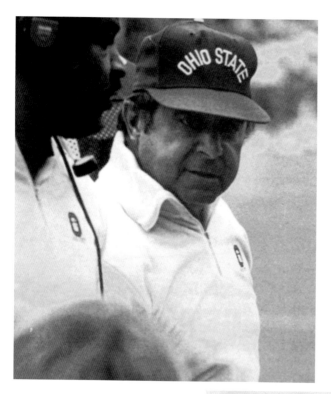

Newly appointed Ohio State head coach Earle Bruce did not wait long to make his presence known to the Wolverine faithful. In his first trip to Michigan Stadium in 1979, Bruce beat the Wolverines, 18-15. Ohio State won the Big Ten Conference and earned a trip to the 1980 Rose Bowl, where the Buckeyes lost to Southern California 17-16. Bruce went on to have an overall record at Ohio State of 81-26-1 and was 5-4 against Michigan. He won the national Coach of the Year award in 1979 and was inducted into the College Football Hall of Fame in 2002. (Ken Magee collection.)

The program from the 1979 matchup between Michigan and Ohio State celebrates the 100th year of Michigan football. Inset photographs on the cover celebrate some of Michigan's historic victories against the Buckeyes, including Tom Harmon's final game in 1940, the 1950 Snow Bowl, and the historic Wolverine victory in 1969. Despite the montage of images, the Wolverines could not muster enough offense and fell to first-year head coach Earle Bruce and his number-two ranked Buckeyes, 18-15. (Jon Stevens collection.)

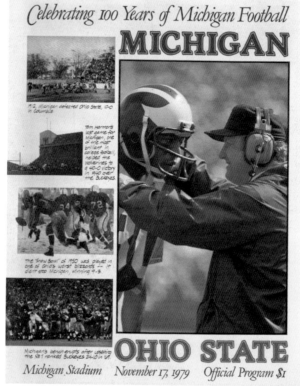

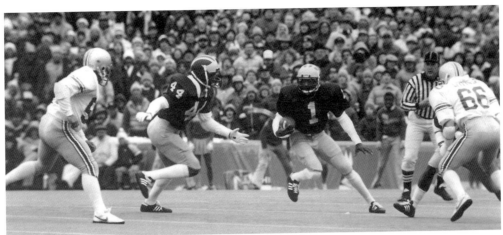

This 1981 game photograph depicts Michigan's three-time All-American wide receiver Anthony Carter. In a battle for the conference title, Ohio State won in a thriller, 14-9. Michigan was inside the Ohio State 10-yard line four times and could only muster three field goals by kicker Ali Haji-Sheikh. The Buckeyes scored a late touchdown by quarterback Art Schlichter, his second of the game. By winning the game, Ohio State shared the Big Ten Conference championship with Iowa. Schlichter and Carter were Big Ten most valuable players in 1979 and 1982, respectively. Anthony Carter was inducted into the College Football of Fame in 2001. (CCP.)

The 1984 matchup was played at Columbus in front of 90,286 spectators. The game was broken open by the Buckeyes in the final quarter, when All-American halfback Keith Byars scored two of his three touchdowns, resulting in a 21-6 Ohio State victory. Byars was the Big Ten most valuable player and Heisman Trophy runner-up in 1984. The Buckeyes won the conference title and traveled to the 1985 Rose Bowl, where they lost to Southern California, 20-17. (CB.)

THE PLAIN DEALER

SPORTS

Gene Williams/**2**
Bob Dolgan/**3**
At the races/**15**

C

SUNDAY, NOVEMBER 23, 1986

Michigan bowls over OSU

Buckeyes miss FG, lose, 26-24

By BURT GRAEFF
STAFF WRITER

COLUMBUS — One swing of Matt Frantz's right leg has significantly altered the holiday travel plans of the Ohio State football team.

Ohio State, which was aimed in the direction of the Rose Bowl, instead is headed for the Cotton Bowl.

"From the time I was in high school," Frantz said, "I dreamed of kicking the field goal that would beat Michigan."

The dream turned into a nightmare yesterday.

Frantz's close miss from 45 yards was the difference in OSU dropping a 26-24 decision to Michigan before a record turnout of 90,674 in Ohio Stadium.

The sixth-ranked Wolverines (10-1, 7-1 in Big Ten play) earned a piece of the conference championship and a trip to the Rose Bowl. They will meet Pac-10 champion Arizona State New Year's Day.

The seventh-ranked Buckeyes (9-3, 7-1) are headed for the Cotton Bowl. They will face either Texas A&M or Arkansas of the Southwest Conference, also on New Year's Day.

The 83rd meeting of Ohio State and Michigan lived up to all its pre-game ballyhooing.

No lead was safe. OSU held a seemingly comfortable 14-3 margin midway through the first quarter. It wasn't enough.

Michigan stormed back to take what looked to be a comfortable 26-17 lead midway through the fourth quarter. It wasn't enough.

It all boiled down to one swing of Frantz's leg. "I thought it was good," said the 5-8, 162-pounder.

"I got good leg into it, but hooked it

Michigan All-American quarterback and team captain Jim Harbaugh (below, No. 4) led the Wolverines to a dramatic come-from-behind victory, 26-24, in Columbus before 90,674 spectators on November 22, 1986. Michigan running back Jamie Morris scored two touchdowns in the game. Harbaugh guaranteed a Michigan win to the media prior to the contest and backed up his words, completing 19 of 29 passes. Harbaugh would go on to be the Big Ten most valuable player, finished third in the Heisman Trophy voting, and had a 15-year career in the NFL. He also had the honor of being the first Wolverine quarterback to throw for 300 yards in a game. A true leader, he became the 20th head football coach for Michigan in 2015. (Above, *The Cleveland Plain Dealer*; below, CP.)

Wolverines Vada Murray (no. 27) and two-time All-American Tripp Welborne (no. 3) leap high in the air to block an Ohio State field-goal attempt in the 1989 battle in Ann Arbor in front of 106,137 fans. The Wolverines won the closely contested game, 28-18, behind running back Leroy Hoard's 152 rushing yards and two touchdowns. This was coach Bo Schembechler's final game against Ohio State and his last time coaching in Michigan Stadium. The victory resulted in Michigan winning the Big Ten championship and a trip to the 1990 Rose Bowl, where the Wolverines lost to Southern California, 17-10. This closed out Schembechler's Michigan career, one of the most successful in college football history. (JA.)

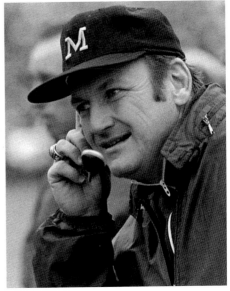

Michigan football coach Bo Schembechler retired following the 1990 Rose Bowl as the winningest coach in Michigan history, with a record of 194-48-5. His teams won or tied for 13 Big Ten Conference championships. Schembechler-coached teams finished in the top 10 nationally 17 times, and he took his teams to 17 bowl games. He was inducted into the College Football Hall of Fame in 1993. (CB.)

Co-author Ken Magee, at age 12, shakes hands with Bo Schembechler at a University of Michigan basketball game in 1971. As a young boy growing up in Ann Arbor, Magee was fortunate to have parents who took him to numerous Wolverine sporting events on the Michigan campus. Coach Schembechler never turned a fan away for a handshake or an autograph. (Ken Magee collection.)

In November 1988, while in fifth grade, co-author Jon Stevens was selected as school mascot Brutus the Buckeye to lead a parade throughout Sutter Park Elementary School in Powell, Ohio, on the Friday prior to The Game. Many schools celebrated with their young students on the Friday before The Game, calling it Michigan–Ohio State Day. Ohio State's Brutus the Buckeye first appeared as the mascot in the 1965 Ohio State–Minnesota game. (Jon Stevens collection.)

6

MICHIGAN DOMINATES
1990 – 2000

In 1990, Michigan found itself without coach Bo Schembechler for the first time in two decades. Ironically, the next head coach for Michigan was an Ohio State graduate. Gary Moeller had played under Woody Hayes in 1960 and 1961 and was captain of the 1962 Buckeye team. Coach Moeller was a longtime assistant for Schembechler before being appointed head coach. Moeller won his first battle against his alma mater, 16-13, on a last-second field goal, knocking the Buckeyes out of the Rose Bowl. This victory started a trend, as Michigan would win 8 of the next 11 games, with one tie. Moeller, who was 3-1-1 against the Buckeyes, was replaced by Lloyd Carr, who would go 5-1 against the Buckeyes during this period. In total, Michigan was 8-2-1 from 1990 to 2000. The Wolverines would win six conference championships during this time, as well as the national championship in 1997 under the leadership of Coach Carr, who was named national Coach of the Year.

After being appointed head coach in 1988, John Cooper led the Buckeyes through 2000. Coach Cooper had a very impressive overall record as the Ohio State head coach (111-43-4), going to 11 bowl games, winning or sharing the Big Ten Conference championship three times, and posting a 73-percent overall winning percentage; however, against Michigan, his overall record was 2-10-1, which was the deciding factor in Ohio State terminating his Buckeye coaching career at the end of the 2000 season. Coaches Carr and Cooper were inducted into the College Football Hall of Fame in 2011 and 2008, respectively.

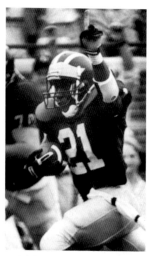

Michigan All-American wide receiver Desmond Howard led the Wolverines to a 31-3 blowout over the Buckeyes in 1991 in Ann Arbor. The win gave Michigan the outright Big Ten Conference championship and a trip to the 1992 Rose Bowl. In the game against Ohio State, Howard showed why he would win the 1991 Big Ten most valuable player award and the Heisman Trophy. Howard's 93-yard punt return electrified the crowd and gave Michigan a 24-3 halftime lead. "I told my friends from Ohio State that if I got in the end zone, I'd do something special for them," said Howard. He punctuated his punt return by striking a Heisman Trophy pose in the end zone. Legendary television announcer Keith Jackson memorialized the moment by bellowing, "Hello Heisman!" Howard was inducted into the College Football Hall of Fame in 2010. (Ken Magee collection.)

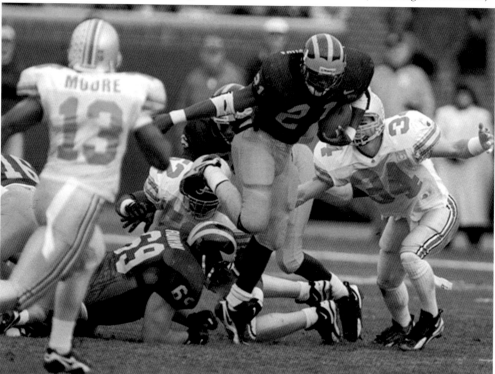

The 1995 game featured an undefeated Ohio State team looking for a Big Ten Conference championship and a Rose Bowl berth against the underdog Wolverines. Sparked by Tim Biakabutuka's 22-yard run on the game's first play, Michigan never let up. Biakabutuka (no. 21) had 313 rushing yards, the most ever gained in a game against Ohio State by a Michigan running back. This also represented the second-greatest day for rushing yardage in Michigan football history, previously established by All-American running back and College Football Hall of Fame member Ron Johnson, who ran for 347 yards against Wisconsin in 1968. Michigan went on to win 31-23 over the Buckeyes. (Ken Magee collection.)

Offensive tackle Orlando Pace played for the Buckeyes from 1993 to 1996. Pace was perhaps the most dominant offensive lineman ever at Ohio State. He so overwhelmed defenders that the term "pancake block," referring to when an offensive lineman knocks a defender on his back, gained popularity at Ohio State. Pace was the Big Ten most valuable player and won the Outland Trophy in 1996. He was selected as an All-American in 1995 and 1996 and was inducted into the College Football Hall of Fame in 2013. (CB.)

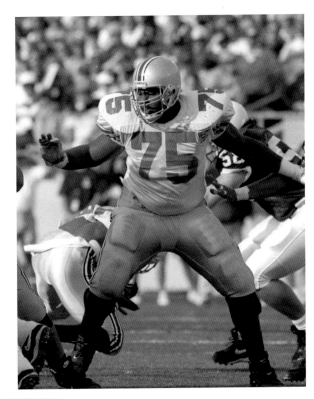

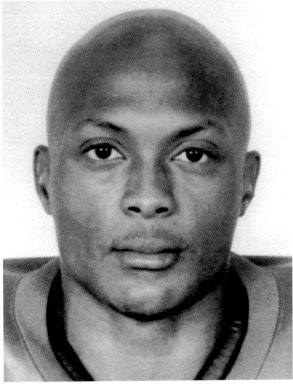

Ohio State All-American tailback Eddie George played for the Buckeyes from 1992 to 1995. As a senior in the 1995 season, George rushed for a school record 1,927 yards and 24 touchdowns, with an average of 152.2 yards per game. George was the Big Ten most valuable player and the Heisman Trophy winner in 1995. His uniform no. 27 was retired by Ohio State in 2001, and he was inducted into the College Football Hall of Fame in 2011. (Ken Magee collection.)

Lloyd Carr was promoted in 1995 as Michigan's interim head coach with the resignation of coach Gary Moeller. Later that year, Carr was promoted to full-time status at the University of Michigan. In his first year, he led the Wolverines to an upset win over Ohio State. Carr went on to post a career record of 122-40 and won five Big Ten championships. Coach Carr won a national championship in 1997 and was also named the national Coach of the Year. Lloyd Carr was elected to the College Football Hall of Fame in 2011. (Jon Stevens collection.)

This is a ticket to the 1997 game, held on November 22. The Wolverines entered the game ranked number one nationally, with the Buckeyes close behind at number four. The Wolverines, led by Heisman Trophy winner Charles Woodson (no. 2), thwarted the Buckeyes with a 20-14 hard-fought victory. The victory sent the future 1997 national champion Wolverines to the 1998 Rose Bowl. (Ken Magee collection.)

OHIO STATE

23	48	15
SEC.	ROW	SEAT

Price: $32.00
Nov. 22, 1997
Time: TBA
Michigan Stadium

7

MICHIGAN

GAME 7

23	48	15
SEC.	ROW	SEAT

OHIO STATE

This is Michigan's 1997 Heisman Trophy winner and All-American Charles Woodson. He was also named Big Ten most valuable player that year. A defensive back, Woodson participated in pregame jabbing with Ohio State All-American wide receiver David Boston before limiting Boston to three catches. In the third quarter, Woodson intercepted a pass by quarterback Stanley Jackson. While Woodson played on both sides of the ball throughout the game, it was his thrilling 78-yard punt return for a touchdown in the second quarter that propelled Michigan to a 20-14 victory and to the 1998 Rose Bowl game. (CP.)

In 1997, the Michigan football team won its 11th national championship and first since 1948. The Michigan defense, led by defensive All-Americans cornerback Charles Woodson, defensive tackle Glen Steele, and nose tackle Rob Renes, was coached by defensive coordinator Jim Herrmann. Herrmann won the 1997 Frank Broyles Assistant Coach of the Year award for his defensive team's effort. The offense was led by quarterback Brian Griese and All-Americans tackle Jon Jansen, guard Steve Hutchinson, and tight end Jerame Tuman. Michigan would go 12-0 and beat Washington State 21-16 in the 1998 Rose Bowl to clinch the 1997 national championship. (BHL.)

Michigan quarterback Tom Brady's record-setting 1998 performance against the Buckeyes was outstanding, with 31 completions on 56 attempts (still an all-time Michigan game record) and 375 passing yards in a 31-16 loss. Brady individually out-dueled Ohio State quarterback and 1998 Big Ten most valuable player Joe Germaine. In 1999, Brady and the Michigan squad would not be denied. Brady threw for two touchdowns in the final 16 minutes of the game to rally the Wolverines from a seven-point deficit to defeat the Buckeyes, 24-17. Brady finished the day completing 17 of 27 passing attempts for 150 yards and two touchdowns. He would go on to be a sixth-round draft pick of the New England Patriots. Brady has developed professionally into a sure-fire NFL hall-of-fame quarterback, winning four Super Bowls. (Ken Magee collection.)

John Cooper was hired from Arizona State in 1988 to replace Earle Bruce as head football coach at The Ohio State University. During his tenure, Cooper compiled an impressive 111-43-4 record, second only to Woody Hayes in total wins. His teams won three Big Ten Conference championships and finished nationally ranked number two twice. Despite his success at Ohio State, his overall record against Michigan was 2-10-1. Coach Cooper was inducted into the College Football Hall of Fame in 2008. (Jon Stevens collection.)

Ohio State Dominates
2001–2014

On January 18, 2001, shortly after Ohio State announced its hiring of Youngstown State University's Jim Tressel as head football coach, Tressel addressed a packed crowd at the Value City Arena during an Ohio State basketball game. Coach Tressel told the crowd how proud they would be, "especially in 310 days in Ann Arbor, Michigan, on the football field." His words were prophetic, as the Buckeyes defeated Michigan that year 26-20 and continued to dominate the Wolverines for the next 10 seasons, winning 9 out of 10. These games from 2001 to 2014 saw a variety of head coaches for both schools, which included Michigan coaches Lloyd Carr, Rich Rodriguez, and Brady Hoke. The 2015 season introduces a familiar face as new head coach for Michigan, Jim Harbaugh, who was Michigan's All-American quarterback and team captain for Bo Schembechler in 1986. Ohio State saw three coaches during this period, including Tressel and Luke Fickell and currently Urban Meyer. Not only did the Buckeyes dominate the Wolverines during this time, they secured eight Big Ten Conference titles and played in 13 bowl games, and both Tressel and Meyer won a national championship, in 2002 and 2014, respectively.

Ohio State coach Jim Tressel was hired in January 2001 and quickly placed an emphasis on beating archrival Michigan. Tressel declared in front of a packed house for a basketball game, "I can assure you that you will be proud of your young people in the classroom, in the community, and most especially in 310 days in Ann Arbor, Michigan." Tressel went on to post a 9-1 record against Michigan and won the national championship in 2002. He was named national Coach of the Year in 2002 and was inducted into the College Football Hall of Fame in 2015. (CB.)

This is a photograph of the 2002 Ohio State University national championship team. Ohio State won the school's seventh national championship by compiling a 14-0 record and defeating the University of Miami (Florida) in the 2003 Tostitos Fiesta Bowl, 31-24, in an overtime thriller. Ohio State was led by Big Ten freshman of the year tailback Maurice Clarett and 2003 Academic All-American of the Year quarterback Craig Krenzel. The team also featured a vaunted defense that included three-time All-American safety Mike Doss and special teams All-Americans placekicker Mike Nugent and punter Andy Groom. (Jon Stevens collection.)

This is the cover of the program for the 2002 game, played on November 23. It displays three-time All-American defensive back Mike Doss. The 2002 game pitted the number-two ranked Buckeyes against the number-twelve Wolverines in Columbus. Freshman tailback Maurice Clarett was the difference-maker on this day despite an injured shoulder. Clarett scored on a two-yard run in the first quarter, and it was his 26-yard catch that set up the go-ahead score for the Buckeyes late in the fourth quarter. This led the Buckeyes to an undefeated record and a spot in the 2003 Tostitos Fiesta Bowl. They defeated the University of Miami (YTM) in overtime, winning the 2002 national championship. (Jon Stevens collection.)

UM-OSU 100th Game
Commemorative Program

$10.00

This is the cover of the 100th game program, played on November 22, 2003. Michigan, in front of a NCAA record 112,118 fans in The Big House, ended a two-game losing streak to Ohio State with a 35-21 victory. Michigan was led by senior quarterback John Navarre, who had 21 completions in 32 attempts, passing for 278 yards with two touchdowns. Both touchdown passes were to future 2004 All-American wide receiver Braylon Edwards, who had a stellar game, catching seven passes for 130 yards. Edwards would go on to become the Big Ten most valuable player and the Biletnikoff Award winner in 2004. (Jon Stevens collection.)

Michigan running back Chris Perry is seen running the football. Perry, an All-American, led the Wolverines to victory in Ann Arbor in 2003. He totaled 154 yards rushing as he consistently found holes in the top-ranked Buckeye run defense. Prior to the game in Ann Arbor, Ohio State was allowing an astonishing 50 yards per game on the ground for the season. Perry won the 2003 Doak Walker Award as the nation's top running back and was named the Big Ten most valuable player. (Jon Stevens collection.)

The 2006 contest was played under the shadow of the death of legendary coach Bo Schembechler. He passed away suddenly on the eve of the game. Pictured here is the original Michigan superfan, Jeff Holzhausen, in the stands in Columbus. Honoring the late coach, Michigan adopted the slogan "Win one for Bo." But, it was not meant to be, as the Buckeyes narrowly defeated the Wolverines, 42-39. (SF.)

The contest on November 18, 2006, was billed as "The Game of the Century." It featured the top-ranked Ohio State Buckeyes against the number-two Michigan Wolverines. The game lived up to the hype. Michigan, however, could not overcome a 14-point deficit in the second half but did get as close as three points. The Buckeyes, in front of a record crowd of 105,708 fans in The Horseshoe, went on to win 42-39, led by Heisman Trophy winner quarterback Troy Smith. Leading the Ohio State defense was three-time All-American linebacker Jim Laurinaitis, who won the Butkus Award in 2007. (Ken Magee collection.)

Ohio State quarterback Troy Smith poses with the 2006 Heisman Trophy. Smith, an All-American, led the Buckeyes to a win over second-ranked Michigan en route to a national championship game appearance. He was also the 2006 Big Ten most valuable player. In the 2006 title game, the Buckeyes fell short against the University of Florida, losing 41-14. Florida coach Urban Meyer became the Ohio State head football coach in 2012. Smith's uniform no. 10 was retired by Ohio State in 2014. (CB.)

Seen here is 2012 and 2013 Big Ten most valuable player Braxton Miller. The quarterback led the 2012 undefeated Ohio State Buckeyes to victory over the Wolverines, 26-21. First-year coach Urban Meyer brought his version of the spread offense to the Big Ten Conference, allowing Miller to flourish in his sophomore season. In 2012, Miller rushed for 1,271 yards and passed for 2,039 yards while accounting for 28 touchdowns (15 passing, 13 rushing). In 2013, Miller rushed for 1,068 yards and passed for 2,094 yards, with 36 touchdowns (24 passing, 12 rushing). (CB.)

This is the cover of the program for the 2014 game, played on November 29. Ohio State, led by running back Ezekiel Elliott and freshman quarterback J.T. Barrett, outlasted the Wolverines 42-28 in Columbus to win the Big Ten East Division crown and a trip to the conference championship playoff game. Against Michigan, Elliott rushed for 121 yards and two touchdowns, including a 44-yard touchdown run on a fourth-down play in the fourth quarter. An unexpected injury to quarterback J.T. Barrett injected replacement quarterback Cardale Jones into action for Ohio State. (Ken Magee collection.)

The 2014 Ohio State University national champion football team gathers for a photograph. The Buckeyes overcame an early-season loss to Virginia Tech by steamrolling through Big Ten opponents. Going 11-1 in the regular season, Ohio State won the Big Ten Conference championship game against Wisconsin, 59-0. This sent the Buckeyes to the first College Football Playoff and a semifinal matchup with Alabama. Ohio State rallied from a 21-6 deficit to beat the Crimson Tide 42-35, earning a spot in the national championship game against Oregon. Led by replacement quarterback Cardale Jones and running back Ezekiel Elliott, Ohio State won its eighth national championship, beating Oregon 42-20. (Jon Stevens collection.)

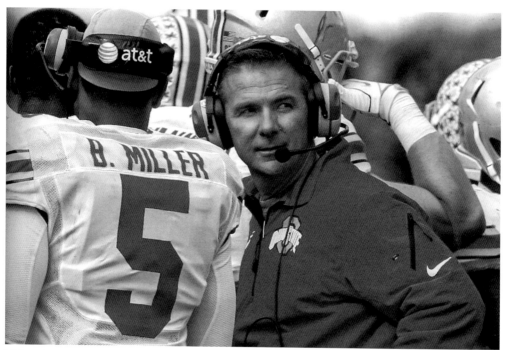

Urban Meyer was hired in 2012 to replace interim coach Luke Fickell, who was at the helm after coach Jim Tressel's resignation at the conclusion of the 2010 season. Coach Meyer quickly turned around a struggling Buckeye football program. Ohio State went 12-0 in his first year, including a victory over the archrival Wolverines. This set the table for bigger things to come. Meyer guided Ohio State to its eighth national title in 2014 in his third year as head coach. He had previously won two national championships while head coach at the University of Florida, giving him three titles in his career as of this writing. (Ken Magee collection.)

On December 30, 2014, Michigan interim athletic director Jim Hackett announced the hiring of former Wolverine quarterback Jim Harbaugh. A 15-year NFL veteran and former San Francisco 49ers head coach, Harbaugh, the 20th head football coach at the University of Michigan, replaced Brady Hoke. Harbaugh stated during his press conference, "During my life I've dreamed of coaching at the University of Michigan. Now I have the honor to live it." (GD.)

SERIES RECORD

DATE	WINNER	SCORE	SITE	ATTENDANCE
Oct. 16, 1897	Michigan	34-0	Ann Arbor	-
Nov. 24, 1900	Tie	0-0	Ann Arbor	3,000
Nov. 9, 1901	Michigan	21-0	Columbus	3,300
Oct. 25, 1902	Michigan	86-0	Ann Arbor	6,000
Nov. 7, 1903	Michigan	36-0	Ann Arbor	5,000
Oct. 15, 1904	Michigan	31-6	Columbus	8,000
Nov. 11, 1905	Michigan	40-0	Ann Arbor	8,000
Oct. 20, 1906	Michigan	6-0	Columbus	6,000
Oct. 26, 1907	Michigan	22-0	Ann Arbor	7,000
Oct. 24, 1908	Michigan	10-6	Columbus	-
Oct. 16, 1909	Michigan	33-6	Ann Arbor	-
Oct. 22, 1910	Tie	3-3	Columbus	-
Oct. 21, 1911	Michigan	19-0	Ann Arbor	5,000
Oct. 19, 1912	Michigan	14-0	Columbus	10,000
Nov. 30, 1918	Michigan	14-0	Columbus	7,000
Oct. 25, 1919	Ohio State	13-3	Ann Arbor	25,000
Nov. 6, 1920	Ohio State	14-7	Columbus	21,000
Oct. 22, 1921	Ohio State	14-0	Ann Arbor	45,000
Oct. 21, 1922	Michigan	19-0	Columbus	71,000
Oct. 20, 1923	Michigan	23-0	Ann Arbor	50,000
Nov. 15, 1924	Michigan	16-6	Columbus	70,000
Nov. 14, 1925	Michigan	10-0	Ann Arbor	47,000
Nov. 13, 1926	Michigan	17-16	Columbus	90,411
Oct. 22, 1927	Michigan	21-0	Ann Arbor	84,401
Oct. 20, 1928	Ohio State	19-7	Columbus	72,439
Oct. 19, 1929	Ohio State	7-0	Ann Arbor	85,088
Oct. 18, 1930	Michigan	13-0	Columbus	68,459
Oct. 17, 1931	Ohio State	20-7	Ann Arbor	58,026
Oct. 15, 1932	Michigan	14-0	Columbus	40,700
Oct. 21, 1933	Michigan	13-0	Ann Arbor	82,606
Nov. 17, 1934	Ohio State	34-0	Columbus	62,893
Nov. 23, 1935	Ohio State	38-0	Ann Arbor	53,322
Nov. 21, 1936	Ohio State	21-0	Columbus	56,277
Nov. 20, 1937	Ohio State	21-0	Ann Arbor	56,766
Nov. 19, 1938	Michigan	18-0	Columbus	64,413
Nov. 25, 1939	Michigan	21-14	Ann Arbor	78,815

Nov. 23, 1940	Michigan	40-0	Columbus	73,480
Nov. 22, 1941	Tie	20-20	Ann Arbor	84,581
Nov. 21, 1942	Ohio State	21-7	Columbus	71,691
Nov. 20, 1943	Michigan	45-7	Ann Arbor	39,139
Nov. 25, 1944	Ohio State	18-14	Columbus	70,449
Nov. 24, 1945	Michigan	7-3	Ann Arbor	85,200
Nov. 23, 1946	Michigan	58-6	Columbus	79,735
Nov. 22, 1947	Michigan	21-0	Ann Arbor	85,938
Nov. 20, 1948	Michigan	13-3	Columbus	78,603
Nov. 19, 1949	Tie	7-7	Ann Arbor	97,239
Nov. 25, 1950	Michigan	9-3	Columbus	79,868
Nov. 24, 1951	Michigan	7-0	Ann Arbor	93,411
Nov. 22, 1952	Ohio State	27-7	Columbus	81,541
Nov. 21, 1953	Michigan	20-0	Ann Arbor	87,048
Nov. 20, 1954	Ohio State	21-7	Columbus	78,447
Nov. 19, 1955	Ohio State	17-0	Ann Arbor	97,369
Nov. 24, 1956	Michigan	19-0	Columbus	78,830
Nov. 23, 1957	Ohio State	31-14	Ann Arbor	101,001
Nov. 22, 1958	Ohio State	20-14	Columbus	79,771
Nov. 21, 1959	Michigan	23-14	Ann Arbor	88,804
Nov. 19, 1960	Ohio State	7-0	Columbus	83,107
Nov. 25, 1961	Ohio State	50-20	Ann Arbor	80,444
Nov. 24, 1962	Ohio State	28-0	Columbus	82,349
Nov. 30, 1963	Ohio State	14-10	Ann Arbor	36,424
Nov. 21, 1964	Michigan	10-0	Columbus	84,685
Nov. 20, 1965	Ohio State	9-7	Ann Arbor	77,733
Nov. 19, 1966	Michigan	17-3	Columbus	83,403
Nov. 25, 1967	Ohio State	24-14	Ann Arbor	64,144
Nov. 23, 1968	Ohio State	50-14	Columbus	85,371
Nov. 22, 1969	Michigan	24-12	Ann Arbor	103,588
Nov. 21, 1970	Ohio State	20-9	Columbus	87,331
Nov. 20, 1971	Michigan	10-7	Ann Arbor	104,016
Nov. 25, 1972	Ohio State	14-11	Columbus	87,040
Nov. 24, 1973	Tie	10-10	Ann Arbor	105,223
Nov. 23, 1974	Ohio State	12-10	Columbus	88,243
Nov. 22, 1975	Ohio State	21-14	Ann Arbor	105,543
Nov. 20, 1976	Michigan	22-0	Columbus	88,250
Nov. 19, 1977	Michigan	14-6	Ann Arbor	106,024
Nov. 25, 1978	Michigan	14-3	Columbus	88,358
Nov. 17, 1979	Ohio State	18-15	Ann Arbor	106,255
Nov. 22, 1980	Michigan	9-3	Columbus	88,827
Nov. 21, 1981	Ohio State	14-9	Ann Arbor	106,043
Nov. 20, 1982	Ohio State	24-14	Columbus	90,252
Nov. 19, 1983	Michigan	24-21	Ann Arbor	106,115

Nov. 17, 1984	Ohio State	21-6	Columbus	90,286
Nov. 23, 1985	Michigan	27-17	Ann Arbor	106,102
Nov. 22, 1986	Michigan	26-24	Columbus	90,674
Nov. 21, 1987	Ohio State	23-20	Ann Arbor	106,031
Nov. 19, 1988	Michigan	34-31	Columbus	90,176
Nov. 25, 1989	Michigan	28-18	Ann Arbor	106,137
Nov. 24, 1990	Michigan	16-13	Columbus	90,054
Nov. 23, 1991	Michigan	31-3	Ann Arbor	106,156
Nov. 21, 1992	Tie	13-13	Columbus	95,330
Nov. 20, 1993	Michigan	28-0	Ann Arbor	106,867
Nov. 19, 1994	Ohio State	22-6	Columbus	93,869
Nov. 25, 1995	Michigan	31-23	Ann Arbor	106,288
Nov. 23, 1996	Michigan	13-9	Columbus	94,676
Nov. 22, 1997	Michigan	20-14	Ann Arbor	106,982
Nov. 21, 1998	Ohio State	31-16	Columbus	94,339
Nov. 20, 1999	Michigan	24-17	Ann Arbor	111,575
Nov. 18, 2000	Michigan	38-26	Columbus	98,568
Nov. 24, 2001	Ohio State	26-20	Ann Arbor	111,571
Nov. 23, 2002	Ohio State	14-9	Columbus	105,539
Nov. 22, 2003	Michigan	35-21	Ann Arbor	112,118
Nov. 20, 2004	Ohio State	37-21	Columbus	105,456
Nov. 19, 2005	Ohio State	25-21	Ann Arbor	111,591
Nov. 18, 2006	Ohio State	42-39	Columbus	105,708
Nov. 17, 2007	Ohio State	14-3	Ann Arbor	111,941
Nov. 22, 2008	Ohio State	42-7	Columbus	105,564
Nov. 21, 2009	Ohio State	21-10	Ann Arbor	110,922
Nov. 27, 2010	Ohio State*	37-7	Columbus	105,491
Nov. 26, 2011	Michigan	40-34	Ann Arbor	114,132
Nov. 24, 2012	Ohio State	26-21	Columbus	105,899
Nov. 30, 2013	Ohio State	42-41	Ann Arbor	113,511
Nov. 29, 2014	Ohio State	42-28	Columbus	108,610

Current 111-game series: Michigan, 58 wins; Ohio State, 47* wins; 6 ties
*Ohio State win in 2010 vacated

DISCOVER THOUSANDS OF LOCAL HISTORY BOOKS FEATURING MILLIONS OF VINTAGE IMAGES

Arcadia Publishing, the leading local history publisher in the United States, is committed to making history accessible and meaningful through publishing books that celebrate and preserve the heritage of America's people and places.

Find more books like this at
www.arcadiapublishing.com

Search for your hometown history, your old stomping grounds, and even your favorite sports team.

Consistent with our mission to preserve history on a local level, this book was printed in South Carolina on American-made paper and manufactured entirely in the United States. Products carrying the accredited Forest Stewardship Council (FSC) label are printed on 100 percent FSC-certified paper.

MADE IN THE